READING'S
BIG LEAGUE
EXHIBITION GAMES

1-30-16

To Mark —

Hope you enjoy the book — check out the 1930 game.

Brian E. Hartz

FRONT COVER: Mike Schmidt jogs to the dugout after hitting his first professional home run in the 1971 exhibition game between the Philadelphia and Reading Phillies. (*Reading Eagle* files.)

COVER BACKGROUND: An aerial photograph of George Field shows a 1946 game between the St. Louis Cardinals and Bowers Battery. (Reading Fightins' files.)

BACK COVER: Babe Ruth and Lou Gehrig pose in the uniforms they wore when their barnstorming tour came to Reading in 1928. (National Baseball Hall of Fame Library, Cooperstown, New York.)

READING'S
BIG LEAGUE
EXHIBITION GAMES

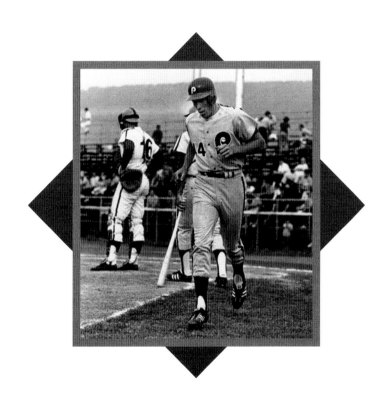

Brian C. Engelhardt
with a Foreword by Dr. David Q. Voigt
and Introduction by Charles J. Adams III

ARCADIA
PUBLISHING

To Suzanne, Christine, Emily, and Elizabeth for the help each of you provided in putting this together. Also to my father, Ted Engelhardt, who got us such good seats at the 1964 game between the Cubs and the Red Sox that we could hear whoever was warming up Cubs starting pitcher Dick Ellsworth distinctly say, as the ball was being tossed back and forth, "I don't know when I went to bed last night because I was too [bleeping] drunk." Seeing the shock on the face of his 12-year-old son, Dad just grinned and said, "Yes, that's what he said." We also saw Ernie Banks and Dick Stuart each hit a towering home run.

Copyright © 2015 by Brian C. Engelhardt
ISBN 978-1-4671-3380-7

Published by Arcadia Publishing
Charleston, South Carolina

Printed in the United States of America

Library of Congress Control Number: 2015932395

For all general information, please contact Arcadia Publishing:
Telephone 843-853-2070
Fax 843-853-0044
E-mail sales@arcadiapublishing.com
For customer service and orders:
Toll-Free 1-888-313-2665

Visit us on the Internet at www.arcadiapublishing.com

CONTENTS

FOREWORD

For nigh unto 150 years, America's major-league baseball spectacular has captivated fans while adapting in lockstep with a changing society.

In 1871, the player-run National Association was established, and by 1903, big-league baseball in America went from player control to owner control under the agreement that produced the dual American and National Leagues. With minor leagues and amateur organizations supplying talent, the enterprise expanded to its present teams.

This oft-told story of big-league glories and frustrations still obtains, but so does the truism "in the beginning were the players." Indeed, players from towns and cities of America and other lands kept on playing the game and delighting fans with their skills. It is this dynamic linkage that still propels the game.

This symbiotic linkage also characterizes Brian Engelhardt's successful forays into Reading's longtime baseball history. His latest work, *Reading's Big League Exhibition Games*, breaks new ground by showing how exhibition games, pitting barnstorming big-league teams and players against local professionals and amateurs, dazzled fans, who, over the years, could see generations of major-leaguers on local fields. Engelhardt's vivid comments are backed by photographs and box scores. It makes for a memorable venture into a neglected dimension of baseball history.

—David Q. Voigt

ACKNOWLEDGMENTS

Support and vital assistance in completing this book have come from a number of people and organizations, to whom thanks are owed. John Horne, National Baseball Hall of Fame coordinator of rights and reproductions, was outstanding with his assistance in researching photographs. Equally outstanding in the help she provided relating to images requested was Tina Urban, director of graphic production of the Philadelphia Phillies, with the Phillies being extremely generous with the photographs shared. Also showing great generosity was T. Scott Brandon (a fellow member of the Society for American Baseball Research, SABR), who not only permitted use of a number of photographs from his private collection, but also provided invaluable guidance. The *Reading Eagle* generously allowed the use of a number of photographs and box scores. Jan Abramowicz of Reading Eagle Press was of great help with the initial formulation of this project. Assistant archivist Lisa Adam, of the Berks County History Center (BCHC) staff, was of great help in finding photographs. Thanks go to the BCHC for permitting their use. Great help came from the Reading Fightins and its executive director of graphic arts, Matt Jackson, not only for contributing photographs, but for enthusiastic support of this project. Thanks also to David Schofield of Belmar, New Jersey, for permitting the use of several photographs, as well as to Andy Schulz of Philadelphia for contributing his time and technological magic in prepping the box scores for publication.

This book would not exist without the support and input provided by former editor of the *Berks County Historical Review*, Donna Reed (as well as by her predecessor, Michele Napoletano Lynch), when this initially took the form of an article in the summer 2012 edition. Thanks also to Rob Hackash, formerly with the Reading Phillies, for originally providing me with the opportunity to contribute to the team's website, the beginning of my baseball writings.

Special thanks are owed to Dr. David Q. Voigt for his splendid foreword, as well as to Charles J. Adams III for his great introduction. Author of several well-respected books and articles on baseball history, Voigt is a former president of SABR and a former "King of Baseballtown." The newest editor of the *Berks County Historical Review*, Adams is renowned for his writings on a wide range of subjects, including baseball, history, travel, and the supernatural. I am grateful for their friendship, as well for as the high standard each has set for the rest of this book.

Photographs credited to the following sources are indicated by abbreviations: National Baseball Hall of Fame Library, Cooperstown, New York (NBHOF); Berks County History Center (BCHC); T. Scott Brandon's private collection (TSB); and the Philadelphia Phillies (Phillies). Box scores are published courtesy of the *Reading Eagle*.

Each of the exhibition games played in Reading is included in the text, organized chronologically with the date and score of that game being the title to a caption. Captions not having the date and score relate to the game referred to in the preceding caption. To avoid repeating certain phrases, the following abbreviations appear in the text: (HOF) indicates induction of that individual into the National Baseball Hall of Fame, (RHOF) means induction of that individual into the Reading Baseball Hall of Fame, (NA) means the National Association of Baseball Players, (NL) means the National League, and (AL) means the American League.

Author royalties from the sale of this book will be donated equally to the Berks County History Center (BCHC, formerly the Berks County Historical Society) and Baseballtown Charities affiliated with the Reading Fightins).

INTRODUCTION

The Phillies played here. The Red Sox played here. The Indians played here. But the Whites, the Colts, the Robins, and the Beaneaters also played here. They played the Reading Phillies, the Reading Red Sox, and the Reading Indians. But they also played the Actives, the Marines, the Keystones, the Steelies, the Pretzels, the Dutchmen, the Coal Heavers, and the All Scholastics.

Christy Mathewson, Rogers Hornsby, Chief Bender, Shoeless Joe Jackson, Mike Schmidt, Pete Rose, Ernie Banks, and Carl Yastrzemski played here. But so did Candy, Deacon, the Orator, Long Levi, Piano Legs, Turkey Legs, Eagle Eye, Boileryard, Pinky, Pud, and Pie. And, oh yes, the Bambino and the Iron Horse also played here.

Keeping this up would be folly. So I will stop here and let Brian Engelhardt step to the plate and introduce you to the players, the managers, and the recaps in *Reading's Big League Exhibition Games*. Even readers with only a casual interest in baseball will enjoy this book. It is a "baseball book," to be sure. But more than that, it is a history book—one that will take its place among the most important such volumes for those who are endeared generally to baseball and specifically to Reading, Pennsylvania. After all, Reading is "Baseballtown," as proclaimed and marketed by the Reading Fightin Phils (former Reading Phillies). This is not an idle boast, as this book helps to validate.

This book chronicles more than a century of seasons, centering on those games in which Reading squads suspended league play or added game days to bring the "stars" to town, which provided a treat for the fans and hopefully filled the tills at the box office. The players on both ends of the contests also benefited from the exhibitions. Aspiring amateurs were given the opportunity to rub gloves with established pros. Visiting "big-timers" could puff up their egos with the admiration of adoring local yokels, pad their wallets, or perform simply for the love of the game. Barnstormers, pickup all-star nines, and major-league teams ventured down on the farm because of certain obligations. In addition, games were arranged just to entertain the fans, and, in the Reading Keystones' case in the late 1920s, to ease the pain.

One of those games was on May 12, 1929, when the Keys, an affiliate of the Chicago Cubs, faced the Pittsburgh Pirates. Sure the fans got to see big-league buccos such as Pie Traynor, the Waner boys, and "Specs" Meadows, but they were thrilled to watch the Keys' own "Unser Choe" Joe Kelly—"the hard hitting Harp from the Pacific coast"—pound three homers and have, as a *Reading Times* account noted, "a perfect day with the willow." Other Keys stars that day included Rabbit Whitman and Chicken Hawks, who totaled "three bingles" between them.

This Keystones franchise was only recently recovering from two of the most dismal seasons in International League history. In 1926, they went 31-129 and set an organized baseball record that still stands by finishing 75 games behind the pennant-winning Toronto Maple Leafs. As a footnote to that season, the Keystones had faced (and lost to) the Maple Leafs in the first-ever game at Toronto's new Maple Leaf Stadium on April 29 before a crowd of more than 12,700.

The following year, the Keys were "improved," compiling a 43-123 record.

The outlook was not brilliant in Baseballtown in those bleak years. But the fans got over it. The franchise retooled. And when the boys from the bigs showed up for that exhibition game in 1929, the Keystone players were eager to see them. The *Reading Times* noted: "The huge mob of 7,122 customers filled practically every inch of the field, packing the stands, two temporary

bleachers in the outfield, and overflowing into the garden. Those spectators not seated under a roof were drenched in the third inning when a pelting shower broke suddenly. The fans took their wetting and liked it. For, they remained to see the sun peek from behind dark clouds and to watch Reading rally to defeat the major leaguers."

Many of the appearances by future Hall of Fame ballplayers and managers were but fleeting moments in Reading's long and proud baseball history. But they were important to fans through several generations. The intimacy of a minor-league stadium positioned fans close to the field and the fielders. Today, the on-deck circle at First Energy Stadium is an arm's length from the front row. The pitcher is farther away from the catcher than are fans sitting behind home plate. To the chagrin of some Eastern League "suits," players walk among patrons on their way to the clubhouses. This is baseball in Baseballtown, and it is the way it was meant to be—intimate, accessible, and exciting. You can feel the dirt. You can smell the sweat. You can see the color of the players' eyes. They call Major League Baseball "The Show." But, truly, the real shows are on America's minor-league fields.

And then there were those exhibitions! That is what this book is all about. It is a playbill for those times when the majors and minors magically mingled.

For a couple of hours on balmy summer nights, under the evening lights, and sometimes in the chill of October, Reading fans were treated to the best in the game, those who came to town to test local amateurs, pros, semipros, and minor-leaguers. Kids (of all ages, as they say) clambered for autographs, photographs, a handshake, a pat on the back, a foul ball, or just a smile and a nod from a diamond idol. And the folks in the front office were more than happy to tally the take of ticket sales.

These appearances often came full circle. Some players made their professional debuts with minor-league clubs in Reading, went on to illustrious careers in the majors, and came back as major-leaguers to face other aspirants in "America's Classic Ballpark." A few were reared or resided near that stadium and played school or sandlot ball, only to make it to the top level and then return as hometown heroes.

Alas, gone are the glory days of preseason or even postseason—often very postseason—exhibition games between parent clubs and affiliates. America's pastime has become a multibillion-dollar business, and the "Boys of Summer" have become multimillion-dollar celebrities with no contractual obligations and no desire to pay a visit to the farms where they were nourished and cultivated.

It is sad to note that the last Reading-Philadelphia AA-MLB exhibition game was, technically, in the last century, as the reader will learn about at the end of this splendid book.

—Charles J. Adams III

Charles J. Adams III is the author of Baseball in Reading, Tales from Baseballtown *and 35 other books on various subjects. In his 35 years as a Reading radio personality, he has emceed many pregame shows for the Reading Phillies/Fightin Phils and . performed the national anthem before several games and at the team's winter banquets.*

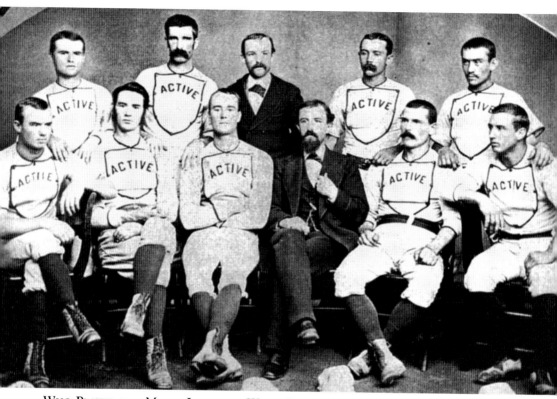

WHO PLAYED THE MAJOR-LEAGUERS WHEN THEY CAME TO READING? Usually the major-leaguers opponent was the local minor-league team. When there was no minor-league team, the major-league team would play local all-stars. Pictured above are the 1875 Reading Actives, a semiprofessional squad that was the home team for most of the exhibition games in the 19th century. In 1883, the Actives became professional, playing in various minor leagues, which changed from year to year as leagues folded because of financial reasons (which the Actives did several times as well). In 1898, Reading's minor-league team became the Coal Heavers for a few years, then from 1907 to 1917 the team was known as the Pretzels or Dutchmen (depending on what historical source is consulted). An issue was financial stability, as over that period seven Reading teams folded or left town during the season, while six leagues in which the Reading teams played each suffered a midseason demise. A period of some stability began in 1919 when a Reading team played in the International League, first as the Coal Barons, then Marines in 1920, then as the Aces in 1921 and 1922, then from 1923 to 1930 as the Keystones or Keys. In August 1932, the Keys moved to Albany and finished the season as the Senators. In 1933 and 1934, Reading's team was the Red Sox, and then for part of 1935, the Brooks (who moved to Allentown in midseason), both of the NY-PA League. In 1940, Reading was home to the Chicks of the Interstate League, who became the Brooks in 1941 following the team's purchase by the Brooklyn Dodgers. From 1952 to 1961, then again in 1965, Reading was home to the Indians, Cleveland's farm team in the Eastern League. Boston's Eastern League farm team, the Red Sox, played in Reading from 1963 to 1964. In 1967, the Reading Phillies of the Eastern League began play here as the AA affiliate of Philadelphia—changing their name to the Fightins as of the 2013 season. (BCHC.)

GAMES PLAYED 1874-1964

What big league teams came to Reading? Since 1874, 72 games were played in Reading by 17 different franchises in three leagues - first in the National Association ("NA"), then in the National League ("NL"), then also in the American League ("AL") (Several games, also listed below, were played by independent barnstorming teams with major leaguers as members, marked as "Ind.") ("V" means the Visiting Team, "H" means the home team.)

Date	Big League Team/Lg.	Manager/ Record		Reading Team/Lg./Mgr. Record		Result	Attendance
9-26-1874	Phil. Whites NA	Bill Craver	29-29 4th	Actives		15-0 (V)	1,000
10-1-1874	Chi. White Stockings NA	Jimmy Wood	28-31 5th	Actives		9-2(V)	1,500
22-1875	Boston Red Stockings NA	Harry Wright	71-8-3 1st	Actives		27-11(V)	+1,000
6-23-1875	Phil. Athletics, NA	Dick McBride	54-20-4 2nd	Actives		18-2(V)	+1,000
10-13-1875	Phil. Whites NA `	Mike McGeary	37-31 5th	Actives		4-4	1,000
10-15-1875	Phil. Whites NA	Mike McGeary	37-31 5th	Actives		9-4 (V)	1,200
10-26-1875	St. Louis Browns NA	Dicky Pearce	39-29-2 4th	Actives		18-11 (V)	unreported
6-10-1876	Chi. White Stockings NL	Al Spalding	55-29 1st	Actives		9-2 (V)	1,200/1,500
7-3-1876	St. Louis Red Sox (Ind.)	Pud Galvin		Actives		5-0 (H)	+1,000
9-1-1876	Cincinnati Reds NL	Charlie Gould	9-56 8th	Actives		9-4 (H)	unreported
8-1-1882	Chi. White Stockings NL	Cap Anson	52-14 1st	Actives		19-4 (V)	2,000
9-5-1890	Boston Beaneaters NL	Frank Sele	76-57-1 5th	Actives		9-1(V)	2,000
9-7-1894	Pittsburg Pirates NL	Connie Mack	65-65-3 7th	Actives (Pa. St.) Whitman	61-50 3rd	6-1(V)	900
4-14-1899	Boston Beaneaters NL	Frank Sele	95-57-1 2nd	Coal Heavers (Atl.) Rinn	46-40 4th	10-3(V)	1,500
10-11-1904	N.Y. Giants NL	John McGraw	106-47 1st	Pros		14-2 (V)	2,000
10-22-1904	Phil. A's AL	Connie Mack	81-70 5th	All Scholastics		5-4(H)	2/3,000
5-10-1905	Phil. A's AL	Connie Mack	92-56 1st	St. Peters		11-1(V)	5,000
10-10-1906	Phil. A's AL	Connie Mack	78-67 4th			2-1 (A's)	1,800
	Vs. Phillies NL	Hugh Duffy	71-82 4th				
10-12-1907	NY Giants NL	John McGraw	82-71 4th	Pros- Coyle		12-0 (V)	2.500
10-15-1907	Phil. A's AL	Connie Mack	88-57 2nd	Pros- Coyle		3-0 (V)	"small"
4-8-1909	Chicago Colts (Ind.)	Cap Anson		Pretzels (Tri St.)Foster	71-43 2nd	10-8 (H)	600
4-10-1909	Phil. A's AL	Connie Mack	95-58 2nd	Pretzels Foster	71-43 2nd	4-3(V)	"big"
10-10-1916	NY Giants NL	McGraw (Herzog) 86-66 4th		Pros		13-0 (V)	1,000
9-23-1920	Washington Americans AL	Clark Griffith	68-84-1 6th	Marines (Intl.) – Hummel	65-85 5th	9-6 (V)	+3,000
8-2-1922	St. Louis Cardinals NL	Branch Rickey	85-69 3rd	Aces-Bender	71-93 6th	9-7 (V)	7/10,000
9-27-1923	Phil. A's AL	Connie Mack	69-83 6th	Keys- Abbot	85-79 3rd	6-6	large
7-23-1925	Brooklyn Robins NL	Wilbert Robinson 68-85 6th		Keys- Shorten	78-90 5th	6-2 (V)	unreported
5-28-1928	Phil. Phils NL	Burt Shotten	43-109 8th	Keys- Hinchman	84-83 4th	7-6 (V)	4/5,000
10-26-1928	Ruth Gehrig Tour	Babe Ruth		Lou Gehrig		9-8 (Babe)	Large/500
5-11-1929	Pittsburgh Pirates NL	Donie Bush	88-65 2nd	Keys- Hinchman	80-86 7th	10-6 (H)	7,122
8-8 -1929	Chicago Cubs NL	Joe McCarthy	98-54 1st	Keys- Hinchman	80-86 7th	6-5(V)	6,175
6-18 -1930	Detroit Tigers AL	Buck Harris	75-79 5th	Keys- Hinchman	68-98 7th	12-7 (H)	unreported
7-20 -1930	Phil. Phils NL	Burt Shotten	53-102 8th	Keys- Hinchman	68-98 7th	13-3 (H)	2,000
7-28-1930	Pittsburgh Pirates NL	Jewel Ens	80-74 5th	Keys- Hinchman	68-98 7th	13-9 (H)	unreported
4-13 -1931	Phil. A's AL	Connie Mack	107-45 1st	Keys- Rowland	79-88 6th	8-3(V)	unreported
4-5 -1932	Phil. Phils NL	Burt Shotten	78-76 4th	Keys- Rowland	71-97 8th	5-2 (V)	"small"
7-5 -1933	Boston Red Sox AL	Marty Macmanus 63-86 7th		Red Sox- Leibold	80-56 1st	6-3 (V)	877
8-6 -1934	Boston Red Sox AL	Bucky Harris	76-76 4th	Red Sox- Leibold	72-66 3rd	9-4 (V)	2,000
8-2 -1937	Phil. A's AL	Connie Mack	54-97 7th	All Stars-Fidler		7-3 (V)	5,300
7-6 1938	Phil. Phils NL	Jimmie Wilson	45-105 8th	Legion All Stars		15-5 (H)	1,500
7-11 -1941	Pittsburgh Pirates NL	Frankie Frisch	81-73 4th	Brooks (Interstate)	74-51 3rd	8-3 (V)	3,127
7-29-1941	Phil. A's AL	Connie Mack	64-90 8th	Brooks-Thompson	74-51 3rd	5-2 (H)	6,000
8-5-1941	Brooklyn Dodgers NL	Leo Durocher	100-54 1st	Brooks-Thompson	74-51 3rd	8-3 (H)	5,300
8-25-1941	Chicago Cubs NL	Jimmy Wilson	70-84 6th	Brooks-Thompson	74-51 3rd	5-2 (V)	3,500
8-30- 1941	Phil. Phils NL	Doc Prothro	43-111 8th	Brooks-Thompson	74-51 3rd	10-1 (V)	1,700
8-24-1944	Brooklyn Dodgers NL	Leo Durocher	63-91 7th	CarT.Steelies		7-5 (V)	3,000
9-15-1944	Phil. A's AL	Connie Mack	72-82 5th	Parish.Steelies		7-1 (V)	3,000
8-5-1946	St. Louis CardinalsNL	Eddie Dyar	98-58 1st	Bowers Battery		12-1 (V)	3,377
10-15-1951	Major Leaguers	Danny Litwhiler		Minor Leaguers –Kurowski		11-4 (Major)	1,500
6-9-1952	Cleveland Indians AL	Al Lopez	93-61 2nd	Rdg Ind. (East.)- Farrell	75-63 3rd	8-1 (V)	6,300
5-18-1953	Cleveland Indians AL	Al Lopez	92-62 2nd	Rdg Indians- Farrell	101-47 1st	4-3 (H)	4,280
6-7-1954	Cleveland Indians AL	Al Lopez	111-43 1st	Rdg Indians - Pinky May	71-69 4th	11-4 (V)	4,290
6-20-1955	Cleveland Indians AL	Al Lopez	93-61 2nd	Rdg Indians JoJoWhite	84-53 1st	5-4 (V)	3,734
4-12-1964	Chicago Cubs NL	Bob Kennedy	76-86 8th			6-3 (Cubs)	5,780
	Boston Red Sox AL	John Pesky	72-90 8th				

THE GOOD, THE BAD, AND THE UGLY. Between 1874 and 1964, the visiting major-leaguers won 35 times, the home team won 13 times, and there were two ties. Counting all big-league teams on this and the next chart for Phillies games, 15 of the visiting teams finished in first place ("the Good") and 11 finished in last, 10 of those teams being the Phillies and one the A's ("the Bad"). Despite the futility of many miserable Phillies teams that visited Reading over the years, the "Ugly" category is reserved for the 9-76 Cincinnati Reds of 1876. (Author's collection.)

Phils -10 Reading Phils 10- Ties 2

DATE	PHILS RECORD/PL	PHILS MGR.	RPHILS RECORD/PL	RPHILS MGR.	SCORE	ATTENDAN
6-8-67	82-80 - 5th	Mauch	70-69 3rd	Lucchesi	8-4 (R)	8,269
7-18-68	76-86 7th	Skinner	81-59 2nd	Lucchesi	7-3 (PH)	7,339
8-7-69	63-99 5th	Myatt	81-59 2nd	Wellman	8-0 (R)	5,005
7-31-70	73-88 5th	Lucchesi	78-63 2nd	Seminick	4-2 (PH)	4,239
6-17-71	67-95 6th	Lucchesi	72-67 2nd	Campbell	4-3 (PH)	3.377
6-5- 72	59-97 6th	Lucchesi	70-69 4th	Bunning	10-2 (PH)	3,432
8-15-74	80-82 3rd	Ozark	69-66 3rd	Wellman	6-3 (R)	6,287
5-29-75	86-76 2nd	Ozark	84-53 1st	Hamner	5-5 tie	4,507
5-10-76	101-61 1st	Ozark	54-82 3rd	Wellman	7-3 (PH)	6,146
4-25-77	101-61 1st	Ozark	63-75 3rd	Wellman	2-1 (R)	4,787
4-26-78	90-72 1st	Ozark	79-57 2nd	Elia	4-3(R)	5,090
4-24-80	91-71 1st	Green	78-61 2nd	Clark	8-4 (R)	7,132
4-30-81	59-48 3rd	Green	76-63 2nd	Clark	6-4(PH)	10,125
4-21-82	89-73 2nd	Corrales	63-75 3rd	Felske	11-7(PH)	6,129
4-14-83	90-72 1st	Owens	96-44 1st	Dancy	5-2(R)	6,785
4- 18-85	75-87 5th	Felske	58-79 8th	Taylor	7-4(PH)	5,432
4-28-88	65-96 6th	Elia	67-69 5th	Dancy	4-3(R)	6,433
4-23-90	77-85 4th	Leyva	55-82 8th	McCormack	7-6 (PH)	6,713
5-14-92	70-92 6th	Fregosi	61-77 6th	McCormack	8-2(R)	6,889
3-31-96	67-95 5th	Fregosi	66-75 4th	Robinson	5-5 tie	8,825
4- 14-98	75-87 3rd	Francona	56-85 5th	LeBoeuf	5-1(PH)	8,878
5-9- 2000	65-97 5th	Francona	85-57 1st	Varsho	5-2(R)	9,307

FOR THOSE KEEPING SCORE AT HOME. As this table shows, fan support in Reading for the 22 games played between the Reading Phillies (RPhils) and the Phillies was usually very good, no matter what kind of season the Phillies were having. Although five of those Phillies teams won their division (two of which won pennants and one the World Series), only eight of those teams finished above .500, with five of them finishing last. Ironically, what would be the final game between the two teams had the second-largest crowd for the entire series, even though the Phillies were on their way to a last-place finish. As engaging as these tables might be, it is the author's hope that the photographs and commentary that follow will bring these games to life. (Author's collection.)

WHEN DINOSAURS ROAMED THE BASE PATHS

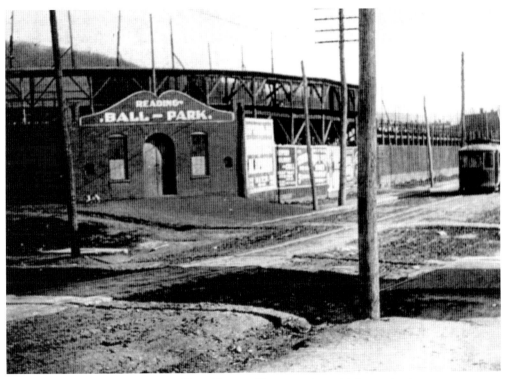

WHEN DINOSAURS ROAMED THE BASE PATHS. Games against visiting major-league teams were played in several different locations in Reading in the late 19th and early 20th centuries. The first such game was played at a park at Nineteenth Street and Perkiomen Avenue, dedicating those "new grounds." Other games were played on the field at Eleventh and Amity Streets (pictured above). (BCHC.)

SEPTEMBER 27, 1874: PHILADELPHIA WHITE STOCKINGS 15, ACTIVES 0. The semipro Reading Actives played the Philadelphia White Stockings, or Pearls (referred to in the local papers as the Philadelphia Giants), of the National Association, which preceded the National League. This game dedicated the Actives' "new grounds" at Nineteenth Street and Perkiomen Avenue in Reading. It was a rough day for the home team, despite the new digs. Behind what the *Reading Eagle* termed his "deceptive delivery," William Arthur "Candy" Cummings (HOF, pictured above) "Chicagoed" the Actives. ("Chicagoed" was the term at that time for shutting a team out.) Credited with inventing the curveball, Cummings kept the Active bats at bay. The high point of the Actives' offense that day was left fielder Frank "Heck" Heifer reaching third base. (NBHOF.)

HALL OF SHAME VIA LOUISVILLE.
Managing the Pearls was William "Bill"
Craver (pictured at right), playing second
base, although he was a catcher for most of
his career. Hitting a career-best .343 that
season, Craver is most remembered as being
a member of the 1877 Louisville Grays,
where he would be one of four players
expelled from baseball for fixing games.
Craver's expulsion was based on his refusal
to cooperate with club officials conducting
the investigation. Returning to his native
Troy, New York, Craver found work as a
policeman. (TSB.)

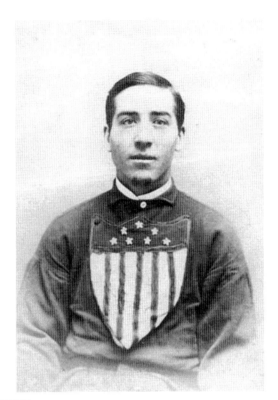

**OCTOBER 1, 1874: CHICAGO WHITE
STOCKINGS 13, ACTIVES 5.** That
season's league batting champion, Levi
Meyerle (.394 average), led the visitor's
attack with three runs scored. The
Reading Eagle noted that, unlike their
last game against a major-league team,
the Actives scored five runs and were
not "Chicagoed." Also making his way
to the hall of shame was Chicago third
baseman Jim Devlin (pictured at left),
who scored two runs. Devlin joined
the 1877 Louisville Grays, with whom
he would admit to throwing games. He
would be one of four Grays barred from
baseball. Following his expulsion, Devlin,
like Bill Craver, found work as a police
officer—but in Philadelphia. (NBHOF.)

ACTIVE.	O	R	BOSTON.	O	R
Goodman, r. f.,	1	1	George Wright. s.s.,	3	4
Waring. s. s.,	3	1	Bea's, 21 b ,	5	2
Hoffman, 1st b.,	3	1	O'Rourke, 3d b ,	2	3
Stott. 3d b ,	4	1	Leonard, l. f ,	5	2
James, 2d b ,	4	1	McVey. c.,	4	1
Heyfert, p.,	2	2	Spaulding, p.,	4	2
Smith, c.,	3	2	H. Wright, r. f.,	1	5
Dillon, l. f.,	4	1	Latham, 1st b.,	1	4
Davis, c. f.,	3	1	Schaeffer, c. f.,	2	4
	25	11		27	27

INNINGS.

	1	2	3	4	5	6	7	8	9	
Active,	0	0	0	3	0	0	0	5	3	—11
Boston,	2	11	2	3	0	0	5	1	3	—27

Base hits for Actives: Goodman 4, Waring 2, Hoffman 2, Stott 2, James 2, Heifert 4, Smith 1, Dillon 2, Davis 2—19. Put out by Actives: by Hoffman 17, Stott 1, James 2, Heifert 3, Dillon 3 and Davis 1. Assisted: Goodman 1, Waring 4, Stott 2, James 4, Heifert 7. Time of game two hours. Earned runs, Bostons 8; Actives 6. Umpire, L. Ressler, who umpired the game very acceptably to both clubs.

MAY 21, 1875: BOSTON RED STOCKINGS 27, ACTIVES 11. Manager Harry Wright's 1875 Boston Red Stockings vanquished nearly every team they played, compiling a 71-8-3 record on their way to the NA championship. Undefeated at the time they came to Reading, the Red Stockings made short work of the Actives, scoring as many runs in one inning as the Actives scored the entire game. (*Reading Eagle* files.)

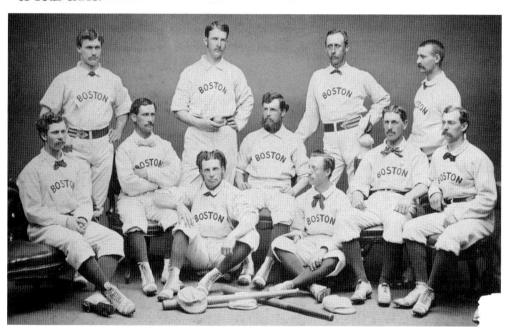

AUSPICIOUS ASSEMBLAGE. Besides Harry Wright (seated, center), five Red Stockings would be inducted into the National Baseball Hall of Fame, including shortstop George Wright (Harry's brother, seated on floor, left), pitcher Al Spalding (standing, second from left), catcher Deacon White (standing, third from left), and outfielder "Orator" Jim O'Rourke (seated, far left). White, second baseman Ross Barnes (seated, second from right), and first baseman Cal McVey (standing, far left) would finish first, second, and third, respectively, in the NA batting race. Spalding's record that year was 54-5. (NBHOF.)

A Star Is Born. Reading Actives outfielder/shortstop/pitcher Frank "Heck" Heifer (pictured at right) had three hits, made several spectacular catches in the outfield, then pitched a few innings. This caught the eye of Harry Wright, who signed Heifer to a contract after the game. Heifer would be the second Reading native to play major-league baseball, making his debut on June 3. Released by Boston in September, he played with the Actives and assorted minor-league teams for the next 12 seasons. (Reading Fireman's Museum.)

Heck and Harry. Manager Harry Wright (pictured at left) referred to Frank Heifer as a ballplayer that "could be depended upon," but Wright was forced to release him in September for economic reasons. Wright was made to keep a player he favored less but who was preferred by Boston's owners. In the 18 seasons that Wright managed after Heifer was released, if Heifer was in attendance at a game Wright was managing, the latter would invite Heifer to sit with him on the bench. (NBHOF.)

J. D. McBRIDE

JUNE 25, 1875: PHILADELPHIA ATHLETICS 18, ACTIVES 2. The Athletics, managed by Dick McBride (pictured at left), won handily while playing in a manner described by the *Reading Eagle* as "careless and uninteresting." The Actives committed 11 errors, causing the newspaper to label the game as "unsatisfactory and detrimental to the interests of baseball in Reading." The *Reading Eagle* also noted the opening of a new pavilion on the grounds, "with a portion dedicated especially for the ladies and gentlemen accompanying them." McBride, who was also the Athletics' top pitcher, was fired as manager and released with eight games left despite his 44-14 pitching record. His salary was the team's highest. (NBHOF.)

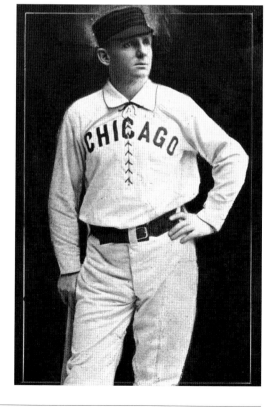

CAP ASCENDING. Replacing McBride as the manager was Athletics' third baseman, Adrian "Cap" Anson (HOF, pictured at right), whose playing career would span 27 years and 3,435 hits. Despite these achievements and being credited with developing several baseball strategies such as the hit and run, the pitching rotation, and spring training, Anson left a legacy that is tarnished by the active role he played in barring African Americans from organized baseball. (NBHOF.)

OCTOBER 13, 1875: PHILADELPHIA WHITES 4, ACTIVES 4; OCTOBER 15, 1875: PHILADELPHIA WHITES 9, ACTIVES 4. The Pearls and Actives played twice in three days. The first game was described by the *Reading Eagle* as "the shortest and best played game of baseball ever witnessed in Reading [in which] the visitors were astounded by the magnificent playing of the home champions." In the rematch, the Actives made 14 errors and were less magnificent. The Pearls were presumably led by second baseman Levi "Long Levi" Meyerle (pictured at right), their best hitter, who twice led the NA in batting. However, the names of visiting players did not appear in either game account. (NBHOF.)

OCTOBER 26, 1875: ST. LOUIS BROWN STOCKINGS 18, ACTIVES 11. In a game described in the *Reading Eagle* with the headline "One of the Worst Games Yet," the Actives made 20 errors and the Browns 12. It is not clear from the game accounts whether any of the errors were committed by Browns outfielder Jack "Death to Flying Things" Chapman. Reading native George Washington "Grin" Bradley (RHOF, pictured at left), who in 1876 would throw the first no-hitter in NL history, pitched the last four innings in relief of a young Pud Galvin. Bradley's nickname came from what the *Sporting News* called the "tantalizing smirk" of his game face. It is a nickname that, according to baseball historian Neil MacDonald, "belied a serious, savagely determined . . . man who wanted to play and win as much as any man alive." Caught up in the festival of errors, the *Reading Eagle* omitted the final score from its game account. Posterity owes its knowledge of the game's details to the *Reading Times*. (NBHOF.)

JUNE 9, 1876: CHICAGO WHITE STOCKINGS 9, ACTIVES 2. With the dissolution of the National Association and creation of the new National League during the offseason, former Red Stocking Al Spalding (HOF, pictured at left) was among the many players to change teams. Now with the White Stockings (eventually the Cubs), Spalding was not only Chicago's star pitcher (47-12), but also its manager. In a game the *Reading Times* called an "Honorable Defeat," the Actives stayed close until giving up five in the ninth inning. (NBHOF.)

NEW POWERHOUSE. Chicago second baseman Ross Barnes (pictured at right) won the batting championship of the new league, hitting .429 as the White Stockings took the first National League pennant. Barnes was one of several former Red Stockings to come to Chicago, along with Spalding, catcher Deacon White (HOF, .343 batting average), and first baseman Cal McVey (.347 batting average). They are joined by former Philadelphia Athletic Cap Anson (.356), forming a team that would win six pennants in the next 10 years. (NBHOF.)

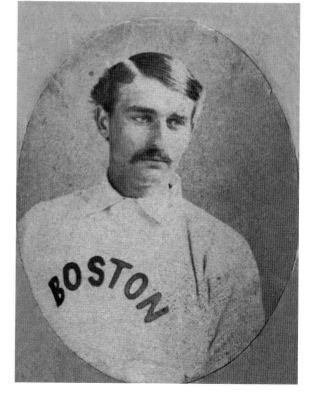

JULY 3, 1876: ACTIVES 5, ST. LOUIS RED STOCKINGS 0. The day before the nation celebrated its centennial, the Actives played the St. Louis Red Stockings, an unaffiliated team comprising several holdovers from the NA's Brown Stockings who did not join new teams. The Stockings are led by 19-year-old Pud Galvin (HOF, pictured at right), who eventually became baseball's first 300-game winner. The Actives surprised the visitors with a victory. According to the *Reading Eagle*, the fielding shown by the Actives was "the most brilliant ever seen on that ground," leaving the visitors "astounded" by its quality. Galvin threw a no-hitter against the Philadelphia Athletics the next day. (NBHOF.)

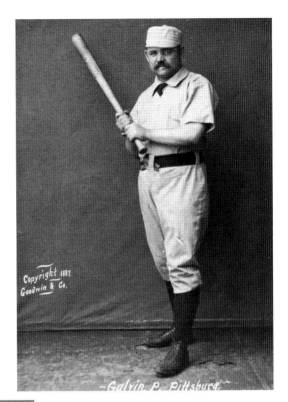

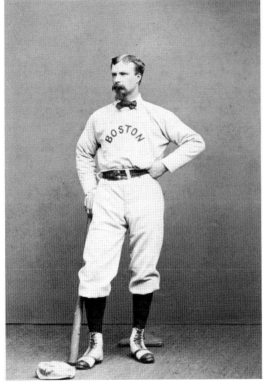

SEPTEMBER 1, 1876: ACTIVES 8, CINCINNATI REDS 4. An unparalleled dimension of "bad" was displayed to local fans with the Reds' visit to Reading. Of the 12 last-place visiting teams playing exhibition games in Reading (10 of which were the Phillies and another being the Philadelphia A's), the worst was the 9-56 Reds of 1876. Manager Charlie Gould (pictured at left) was challenged with a starting lineup featuring three regulars batting .200 or lower and no pitchers with more than four victories. Following their loss to the Actives, various Reds were quoted by the *Reading Eagle* as saying that "They had never met with a finer amateur club of ball players." (NBHOF.)

AUGUST 1, 1882: CHICAGO WHITE STOCKINGS 19, ACTIVES 4. The White Stockings won handily, led by Cap Anson (three hits, eight times on base), Michael "King" Kelly (five hits, triple, home run, four runs scored), and George "Piano Legs" Gore (two hits, five runs scored). Gore (pictured at left)—his nickname earned for obvious reasons—hit above .300 most years of his career, until, according to Anson, "Wine, women and song brought him down." The visitors received $200 for their trouble; the total gate was $400. The *Reading Times* termed the Actives' effort "A Creditable Showing." (NBHOF.)

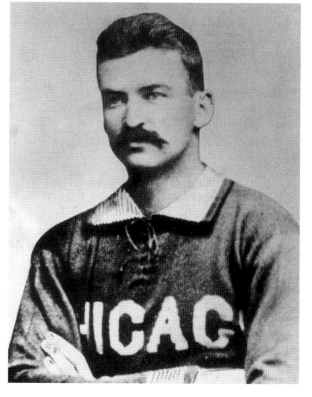

SLIDE, KELLY, SLIDE. Michael "King" Kelly (HOF, pictured at right) was probably the most famous baseball player of the era. Flamboyant on and off the field, he led the league in hitting twice, hit over .300 eight times, and was on eight pennant-winning teams. Notorious for driving umpires crazy and bending the rules, Kelly was the subject of the popular song, "Slide, Kelly, Slide." (NBHOF.)

SEPTEMBER 5, 1890: BOSTON BEANEATERS, 10, ACTIVES 1. Led by catcher Lou Hardie's four hits, the visitors (who would become the Braves) won what the *Reading Times* called, "A pretty game in which Reading . . . held its end up well." The *Reading Times* also reported that the local Germania band enhanced the occasion, as it "discoursed enchanting music between innings." Rookie pitcher Kid Nichols (HOF, pictured at right), winner of 27 games that year and 361 in his career, played right field for the visitors. (NBHOF.)

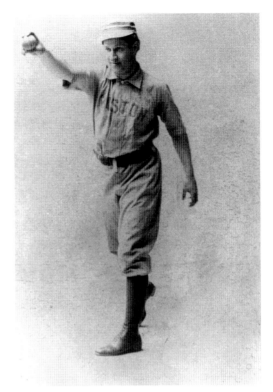

BUT HE DID NOT WRITE THE POEM. Manager Frank Selee (HOF, pictured at left) led the Beaneaters to five pennants in 13 years of managing the team. With his teams implementing new strategies of bunting and stealing bases, he compiled a .598 career winning percentage, the fourth-highest in history. Released by Boston after the 1901 season, Selee went to Chicago, where he managed for four seasons and assembled the infield of Joe Tinker, Johnny Evers, and Frank Chance. (NBHOF.)

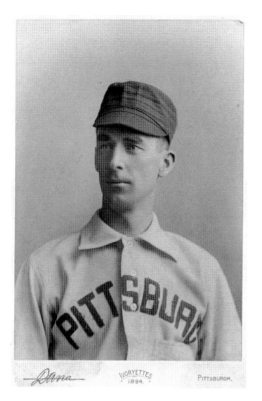

SEPTEMBER 7, 1894: PITTSBURG PIRATES 6, ACTIVES 1. In the first of 10 games that teams managed by Connie Mack (pictured at left) would play in Reading, Pittsburg (it was officially spelled without the "h" between 1890 and 1911) handily defeated the Actives, led by Jake Beckley's three hits. Mack, appointed manager just four days earlier, played first base instead of his usual position at catcher. The Mack Men commeth. (NBHOF.)

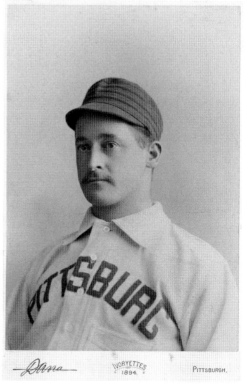

A FIRST. Holding the Actives to five hits was Tom Colcolough (pictured at right), whose niche in baseball history was established on June 23, 1893. While pitching for the Charleston Seagulls (Southern Association), Colcolough threw the first professional no-hitter after the pitcher's box was replaced with a rubber and was moved to 60 feet, 6 inches from home plate. Singling for the Actives was their leading hitter, William Shakespeare Wetzel (known as "Shorty" rather than "The Bard"), who that season batted .325. (NBHOF.)

BIG DAY FOR EAGLE EYE.
Spearheading the Pirates offense
that day with three hits, including a
double, was Jake "Eagle Eye" Beckley
(HOF, pictured at right), playing in
left field instead of his usual first base.
Over the course of his 20-year career,
nine of which were in Pittsburg,
Beckley amassed 2,934 hits, batting
over .300 fifteen times. (NBHOF.)

OLD JUDGE CIGARETTES Goodwin & Co
New York.

BEFORE MAZ. The *Reading Eagle* described
how Pirates second baseman Lou Bierbauer
(pictured at left) "robbed Reading of at least
four hits by the most phenomenal pickups of
grounders ever seen here." Known better for
his fielding at second base than his offense,
Bierbauer brings to mind a future Pirate second
baseman now in the National Baseball Hall of
Fame. Pittsburg's 1891 signing of Bierbauer
away from the Philadelphia Athletics of
the American Association led to the team's
nickname—"Pirates." (NBHOF.)

APRIL 14, 1899: BOSTON BEANEATERS 10, COAL HEAVERS 3. The Coal Heavers opened the 1899 season with a loss to the defending National League champions. For the visitors, Hugh Duffy (HOF, pictured at left) had two hits, including a triple, with two RBI and a run scored. Duffy's league-leading .440 batting average in 1894 represents the single-season record. Although Reading eked out only four hits, the *Reading Times* wrote, "Defeat was anything but discreditable." (NBHOF.)

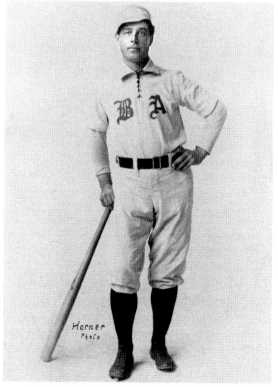

HOT CORNER PIONEER. Prominent in Boston's attack that day was third baseman Jimmy Collins (HOF, pictured at right), who singled twice and drove in a run and scored. Collins would set the standard for fielding the third base position during his 14-year career, excelling on fielding bunts and throwing runners out from all positions. Usually among the leaders in offense for third basemen, Collins hit above .300 five times, leading the league with 15 home runs in 1898. (NBHOF.)

STOLEN STEALER. Billy Hamilton (HOF, pictured at right), known as "Sliding Billy" because of his 914 stolen bases, scored 198 runs in 1894, still the all-time record. Hitting below .300 only twice in his 14-year career, Hamilton batted .403 in 1894. After the 1895 season, the Phillies traded him to Boston for Billy Nash, who played three more years, never hitting above .258. Hamilton batted above .300 in five of his six years with Boston, helping the team win two pennants. (NBHOF.)

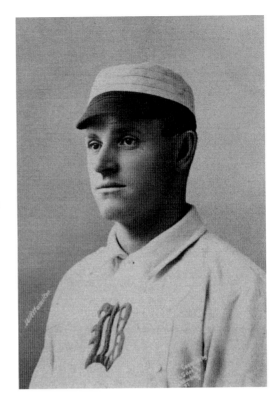

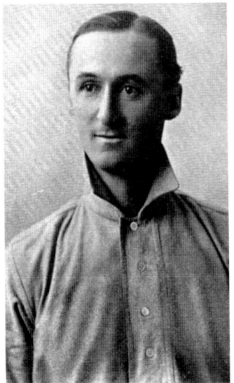

BOILERYARD'S BIG DAY. Handling duties behind the plate for the visiting team in these exhibition games would usually be the backup catcher, providing a day off for the regular catcher. Such was the case when reserve catcher William "Boileryard" Clark (pictured at left) led Boston with three hits, including a double and a triple, two runs scored, and one RBI. Clark, whose magnificent nickname came from his deep, ear-piercing voice, eventually escaped a backup role, emerging as Washington's starting catcher for a few seasons near the end of his 13-year career. (TSB.)

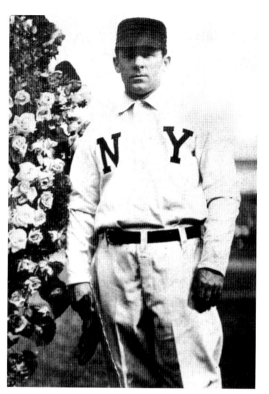

October 11, 1904: New York Giants 14, Local Pros 2. Contemptuous of the upstart American League, "The Little Napoleon" John McGraw (HOF, pictured at left) had his pennant-winning Giants go barnstorming rather than play the Boston Americans (later the Red Sox) in a so-called "World Series." The players' share of the barnstorming revenues more than made up for what they would have earned playing Boston. Their opponents in Reading were a group of overmatched local professionals called the All Scholastics. (NBHOF.)

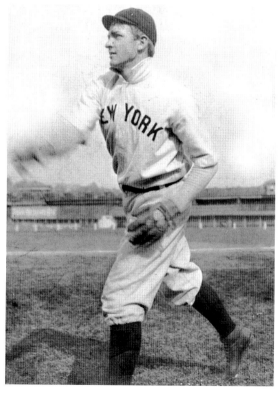

Matty the Great. Christy Mathewson (HOF, pictured at right) shows local fans why, in the words of the *Reading Eagle*, he was "the pitching wonder of the National League . . . [and] did not have to exert himself." He scattered nine hits in the Giants' victory. The Giants were described by the *Reading Eagle* as "probably the fastest aggregation of ball players who have ever played here, [capturing] everything that came within their reach." (NBHOF.)

WHEN DINOSAURS ROAMED THE BASE PATHS

OCTOBER 21, 1904: ALL SCHOLASTICS 5, PHILADELPHIA ATHLETICS 4. Connie Mack agreed that the Athletics would play the All Scholastics, a Reading all-star team. It was advertised that the pitcher for the visitors would be Rube Waddell (HOF, pictured at right), winner of 25 games that season. With either 2,000 or 3,000 fans in the stands (depending on which Reading newspaper one read), Waddell failed to show, going on an impromptu hunting trip instead. (NBHOF.)

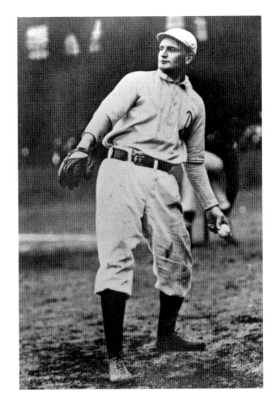

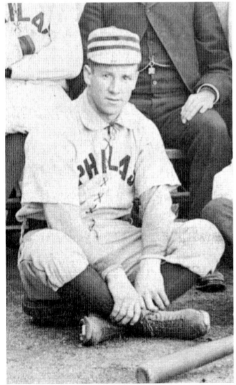

ONLY FOOLING. NOT. Under the headline "The Athletics Fooled Until It Was Too Late," the *Reading Eagle* related how the visitors played with the usual looseness characteristic of barnstorming games, while the home team played the game with far more intensity. Bearing down the entire game, the All Scholastics rallied for three in the eighth inning. Playing for the visitors that day was Phillies second baseman (and future Black Sox manager) Kid Gleason (pictured at left), who led their attack with three hits. (NBHOF.)

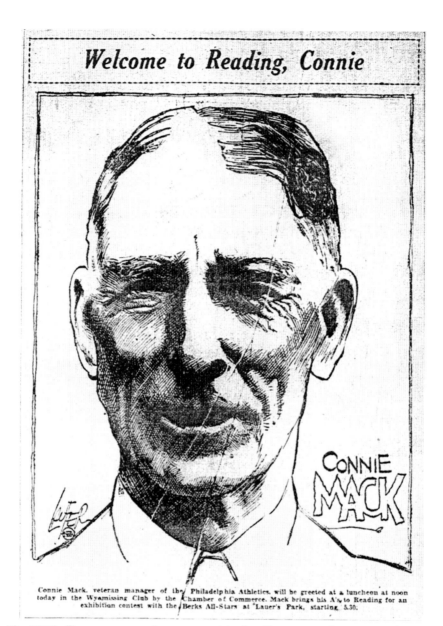

Welcome to Reading, Connie

Connie Mack, veteran manager of the Philadelphia Athletics, will be greeted at a luncheon at noon today in the Wyomissing Club by the Chamber of Commerce. Mack brings his A's to Reading for an exhibition contest with the Berks All-Stars at Lauer's Park, starting 5.30.

MAY 10, 1905: PHILADELPHIA ATHLETICS 11, ST. PETERS 1. Connie Mack (HOF) was persuaded to play a benefit game on an off-day by an old friend, the priest at St. Peters in Reading. This resulted in a delay in departing for a road trip and the loss of a free day in St. Louis, which upset the players. St. Peters managed one run as Eddie Plank (HOF) and Chief Bender (HOF) dominate. The train the team originally would have taken was involved in a wreck in which more than 20 people were killed and 100 injured. In view of what they avoided by the day's delay, the players were not that upset about the game in Reading after all. St. Peters raised $1,000 from the game, the largest amount collected in any single event in its history to that time. The Athletics go on to win the 1905 pennant. The Lord works in strange and wondrous ways. (*Reading Eagle* files.)

The score was as follows:

Athletics.	A.B.	R.	H.	O.	A.	E.
Hartzel, lf.	4	0	0	0	0	0
Davis, 1b.	4	0	0	10	0	0
Seybold, rf.	4	0	1	2	0	0
Bender, 2b.	4	0	1	0	1	0
Oldring, 3b.	3	1	1	3	1	0
Litschi, ss.	3	1	0	1	3	0
Plank, cf.	3	0	1	1	0	0
Powers, c.	3	0	2	10	1	0
Coombs, p.	3	0	1	0	2	0
Totals	31	2	7	27	8	0

Philadelphia.	A.B.	R.	H.	O.	A.	E.
Duffy, cf.	4	0	0	3	0	0
Gleason, 2b.	4	0	0	3	0	0
Bransfield, 1b.	4	0	1	8	2	0
Titus, rf.	4	0	0	1	0	0
Magee, lf.	4	1	1	1	0	0
Courtney, 3b.	3	0	2	0	1	0
Doolin, ss.	4	0	1	3	4	0
Dooin, c.	2	0	0	5	1	0
Sparks, p.	2	0	0	0	4	0
Totals	31	1	5	24	12	0

Philadelphia............0 0 0 0 1 0 0 0 0—
Athletics............ 0 0 0 0 0 0 2 0 x—

Two base hits—Coombs, Magee Doolin, Courtney. Stolen bases—Brans field, Gleason. Bases on balls—Off Coombs, 2. Hit by pitcher—Courtney Struck out—By Coombs, 8; by Sparks 3. Left on bases—Philadelphia, 7; Ath letics, 5. First base on errors—Ath letics, 1. Umpires—Schreck and Dono van.

OCTOBER 10, 1906: PHILADELPHIA ATHLETICS 2, PHILLIES 1. In the first of two "Clashes of the Titans," in which two major-league teams opposed one another in Reading, rookie Jack Coombs outpitched the Phillies' Tully Sparks. Playing center field for the Phillies that day was their 39-year-old manager, Hugh Duffy (HOF), who went 0-4. The Reading Eagle described the game as "lively," but added, "The finish was halfhearted, as the Phillies had to leave on the 5:55 train." (Reading Eagle files.)

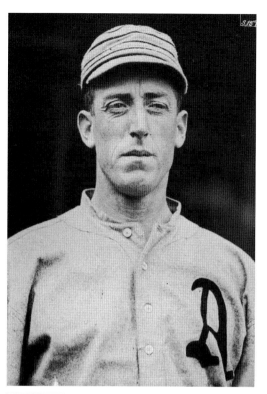

RABBIT RUN. Playing center field for the Athletics was pitcher "Gettysburg" Eddie Plank (HOF, pictured at left), who compiled 326 lifetime wins. Plank's 19-6 record and winning percentage (.760) led the league that year. He initiated the game's high point in the fourth inning, when, while in the field, he began to chase a rabbit that sprinted in front of him. (NBHOF.)

RABBIT REDUX. Pitcher Charles Albert "Chief" Bender (HOF, pictured below), playing second base, joined Plank in chasing the rabbit, followed by players on both teams, including two Phillies who had been on base. The rabbit escaped through a hole in the fence. The *Reading Eagle* declared that this "amused the audience more than any play in the game." In 1922, Bender would manage the Reading Aces. (NBHOF.)

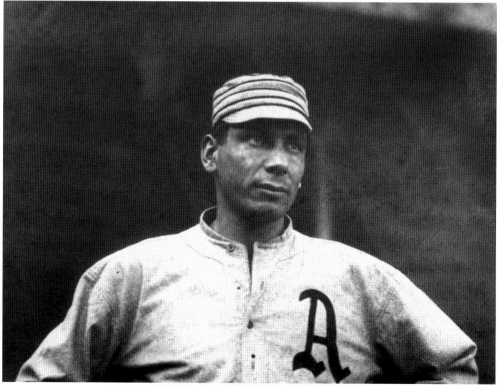

WHEN DINOSAURS ROAMED THE BASE PATHS

PHILLIES OFFENSE. Left fielder Sherry Magee (pictured at right) doubled and scored, the Phillies' only offense that day. Magee's .282 average led Phillies hitters that season, one of 11 that he would spend with the team. An offensive star over the course of his 16-year career, Magee hit above .300 six times, winning the batting title in 1910. He led the league in RBI on four occasions. His reputation as a troublemaker left a clouded legacy. (NBHOF.)

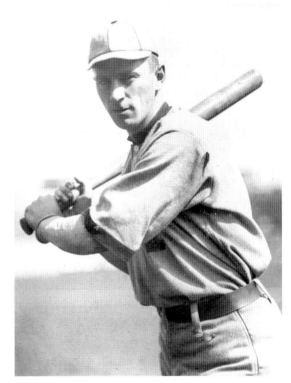

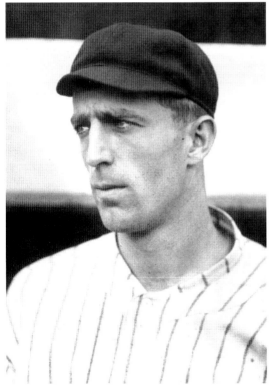

OCTOBER 12, 1907: NEW YORK GIANTS 12, READING PROFESSIONALS 0. Calling Reading a "great baseball city," Christy Mathewson stifled a team of minor-leaguers, allowing four hits, no runs, and striking out 14. Playing first base for the Giants was 18-year-old Fred Merkle (pictured at left), less than one year short of the September 23, 1908, game in which his base running error resulted in his being unfairly saddled with the nickname of "Bonehead." An excellent fielder and talented hitter over a 16-year major-league career, Merkle was frequently consulted by Giants manager John McGraw when questions on strategy arose. Merkle would manage the 1927 Reading Keystones, which compiled a 31-game losing streak in the course of a season during which Merkle would be fired, rehired, and then fired again. (NBHOF.)

HOOKS. In left field for the Giants that day was pitcher George "Hooks" Wiltse (pictured at left), whose brother Lew played for the pennant-winning Reading Atlantic League team that season. His nickname came from his fielding prowess, not his curveball. Wiltse managed the 1916 and 1917 Reading Pretzels of the New York State League. For a portion of the 1926 season, he managed the abysmal Reading Keystones (31-129) of the International League. (NBHOF.)

OCTOBER 15, 1907: PHILADELPHIA ATHLETICS 3, READING PROFESSIONALS 0. Just three days after being shut out by Christy Mathewson, the same Reading Professionals, predominantly members of that year's pennant-winning Atlantic League team, faced two other future members of the Hall of Fame: Rube Waddell (not hunting that day) and Eddie Plank, who, with Jack Coombs, also shut them out. It was not like that in the Atlantic League. Plagued by arm problems over a 14-year career, Coombs (pictured at right) led the AL in victories in 1910 (31) and 1911 (28). Following his playing career, Coombs coached baseball at Williams, Princeton, and Duke. (NBHOF.)

WHEN DINOSAURS ROAMED THE BASE PATHS

APRIL 8, 1909: READING DUTCHMEN/ PRETZELS 10, CHICAGO COLTS 8. Cap Anson, 56, brought an independent team to play the Pretzels, or Dutchmen (depending on the source). Anson singled and scored twice. He was described by the *Reading Eagle* as hustling "around in the same style as 20 years ago." Jack Lelivelt (pictured at right) had three hits for Reading and would bat .345 until June, when he was sold to Washington. There, he hit .292 in 91 games, the top average on the team. (TSB.)

APRIL 10, 1909: READING DUTCHMEN/ PRETZELS 5, PHILADELPHIA ATHLETICS 4. Reading edged an Athletics team made up of young players referred to by Connie Mack as his "Colts." Homering for the visitors was "Shoeless Joe" Jackson (pictured at left), who would play 10 games with Philadelphia over two seasons before being traded to Cleveland. After 13 years in the major leagues, in which Jackson compiled a .356 batting average, his career ended with the Black Sox scandal. However, at this point in time the phrase, "Say it ain't so, Joe," would only have been applicable to Jackson's future in Philadelphia. (NBHOF.)

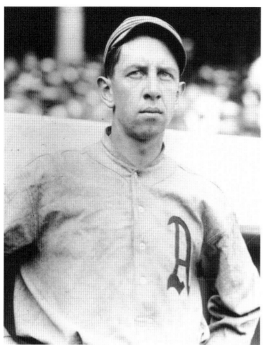

BIG YEAR AHEAD. Another "Colt" in the Philadelphia lineup getting a hit was Eddie Collins (HOF, pictured at left). The Columbia University graduate had a breakout year in 1909, hitting .347 with 198 hits and establishing himself as the team's regular second baseman. Collins amassed 3,315 hits in a 25-year career in which he would hit over .300 19 times, compiling a .333 lifetime average. (NBHOF.)

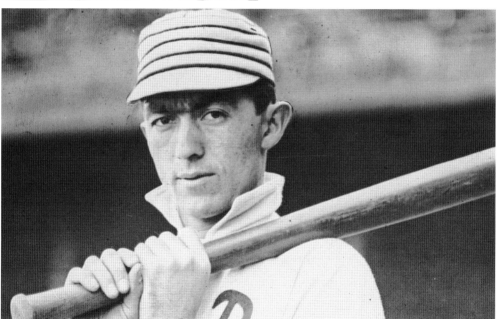

$100,000 INFIELD. Out that day due to injury was third baseman Frank "Home Run" Baker (HOF, RHOF). Baker (pictured above) played with Reading the previous season before his contract was transferred to the Athletics in September. Playing third base in his place was 19-year-old John "Stuffy" McGinnis, who tripled that day. In 1911, McGinnis would become Philadelphia's regular first baseman, joining Baker, Collins, and shortstop Jack Barry in Mack's "$100,000 infield." (NBHOF.)

IF YOU BUILD IT, SOME OF THEM WILL COME (IF YOU HAVE A GOOD TEAM)

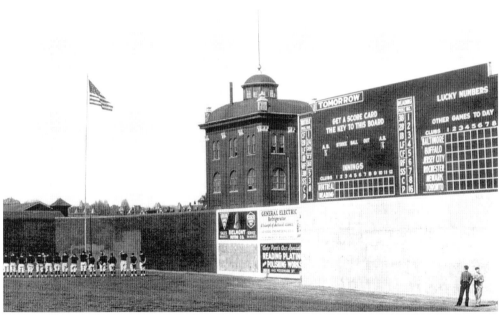

IF YOU BUILD IT, SOME OF THEM WILL COME. The site of the exhibition games from 1916 to 1941 was Lauer's Park (pictured above), situated at Third and Buttonwood Streets. Initially constructed in 1907, on July 4, 1911, the ballpark experienced growing pains, as a portion of it collapsed during a Reading Pretzels game, injuring 30 spectators. It was poorly maintained when it was occupied, as low attendance and poor revenues plagued the teams that called it home (most of which were not very good). With no team occupying it and in a state of disrepair, it was demolished in 1943. (BCHC.)

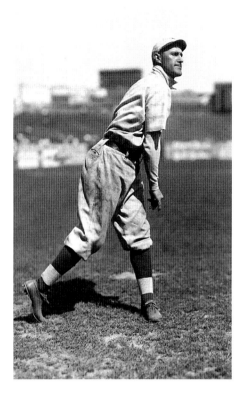

OCTOBER 10, 1916: NEW YORK GIANTS 13, PROS 0. Noting that the "Reading boys," a group of minor-leaguers, faced "the same lineup that recently won 26 straight games and established a new world's record for consecutive wins," the *Reading Eagle* complimented the Giants for backing off once they established a lead in the rout. Second baseman Heine Zimmerman and shortstop Art Fletcher (pictured at left) paced the Giants with three hits each. Fletcher spent 11 years of his 13-year career as the feisty heart of the Giants. (TSB.)

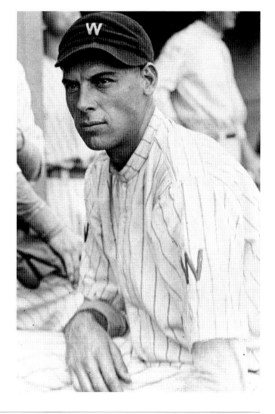

SEPTEMBER 23, 1920: WASHINGTON SENATORS 9, READING MARINES 6. So that Reading fans could honor Frank "Turkeylegs" Brower (pictured at right), sold to the Senators in mid-August after hitting 22 home runs for the Marines, the Senators played the Marines. The fans show their gratitude by awarding Brower a watch and a $50 check. Brower rewards the 3,200 in attendance by hitting a double. Sparked by shortstop Jim O'Neill's two-run homer (he would hit only one in his entire big-league career), Washington rallies for the victory with four runs in the ninth. (TSB.)

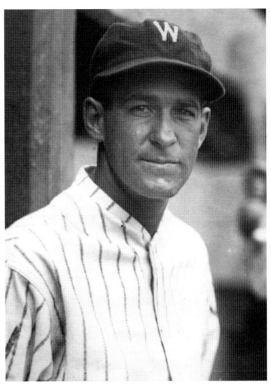

SIX DEGREES OF BUCKY HARRIS. A former member of the 1917 Reading Pretzels, Bucky Harris (HOF, RHOF) singled and scored twice in the first of his several returns to Reading. The 1920 season would be Clark Griffith's (HOF) last managing Washington. Harris (pictured at right and below) took over in 1924. Harris would return to Reading as manager of the 1930 Detroit Tigers and then again in 1934 as manager of the Boston Red Sox. (Both, NBHOF.)

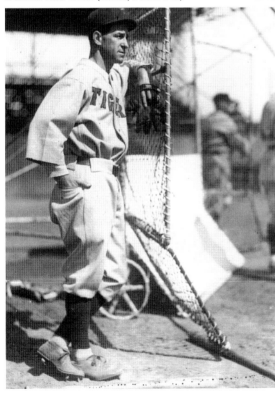

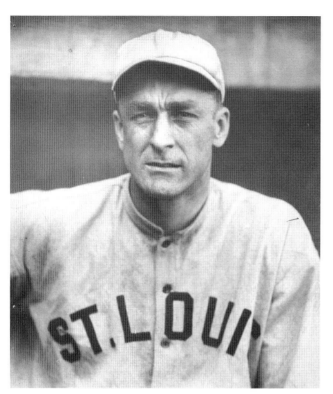

AUGUST 2, 1922: ST. LOUIS CARDINALS 9, READING ACES 7. Before he was known as the "Mahatma," Branch Rickey (HOF, pictured at left) was persuaded to bring his Cardinals to Reading when the Aces' business manager promised that Myrl Brown, the Aces' best hurler, would pitch. Thinking this might be a chance for a possible acquisition, Rickey, out of uniform, sat in the press box to watch Brown more closely, poised with paper and pencil to take notes. (NBHOF.)

BEST OF THE WORST. In front of a huge crowed of either 7,000 or 10, 000 (depending on which Reading newspaper is consulted), the Cards scored seven runs off Myrl Brown (pictured at right) in the second inning, including a three-run homer by Rogers Hornsby (HOF). Rickey threw his pencil down and stopped taking notes. Brown was the best pitcher on the Aces and had been since 1919. Of course, the team had never finished above sixth place. Sold to the Pirates near the end of the season, Brown played in seven games with a record of 3-0 but did not appear in a major-league game after that. (TSB.)

IF YOU BUILD IT, SOME OF THEM WILL COME

SEPTEMBER 27, 1923:
PHILADELPHIA ATHLETICS 6,
KEYSTONES 6. A's second baseman
Jimmy Dykes (pictured at right)
singled and scored a run. Dykes spent
15 of his 22 big-league seasons with
the A's, then managed the team for
three seasons and was an important
component of the pennant-winning
teams of 1929–1931. In 1960, as
manager of the Detroit Tigers, he was
traded to Cleveland for its manager,
Joe Gordon, in one of "Trader Frank"
Lane's most famous deals. (NBHOF.)

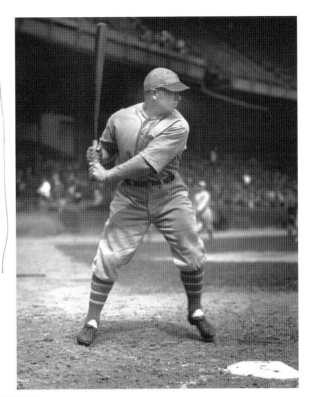

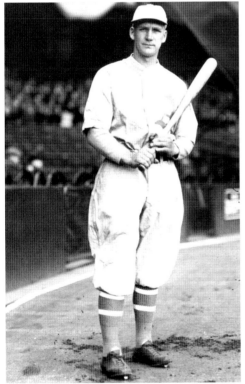

UNSER CHOE. Leading the A's attack that
day was first baseman Joe Hauser (pictured at
left) with two hits, including a double. Known
as "Unser Choe" throughout his career, the
24-year-old Hauser led the Athletics in home
runs and RBI in 1923 and 1924. Waived by
the A's when his hitting declined, Hauser
spent 11 years in the minors clubbing home
runs, including 63 with Baltimore in 1930 and
69 with Minneapolis in 1933. (NBHOF.)

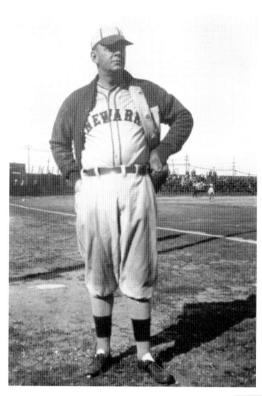

KEYSTONE'S ACE. The Key's Al Mamaux (pictured at left) pitched eight innings of shutout ball to preserve a tie as the 12-inning game (unheard of in exhibition matches) was called on account of darkness. After an 11-year big-league career that would include a pair of 20-win seasons with Pittsburgh, Mamaux joined the Keys, pitching a one-hitter against Lefty Grove and the Baltimore Orioles. His 17 wins that season led the Keys staff. (TSB.)

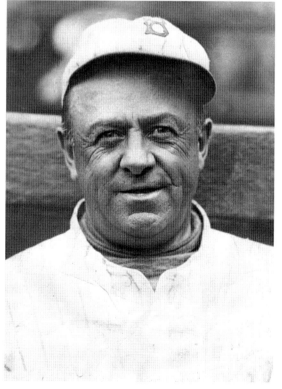

JULY 23, 1925: BROOKLYN ROBINS 6, KEYS 2. Known as the Robins during the time it was managed by Wilbert Robinson (HOF, pictured at right), Brooklyn put the game away with three runs in the eighth inning. Known as "Uncle Robbie," Robinson spent 10 seasons of his 17-year playing career in Brooklyn, then managed the team from 1914 to 1931, winning two pennants. The Hubbell pitching for the Robins that day was Billy, not Carl. (NBHOF.)

IF YOU BUILD IT, SOME OF THEM WILL COME

TROUBLED UNCLE ROBBIE. In left field going 0-3 for the Robins was Zack Wheat (HOF, pictured at right), who batted .359 that year. Hitting over .300 fourteen times in a 19-year career, Wheat compiled a .317 lifetime average. Earlier that season, team president Ed McKeever appointed Wheat player-manager and moved Robinson to the front office. This assignment lasted only briefly, as McKeever died suddenly. Robinson returned to the helm. Robinson's belief that Wheat wanted his job created tension between the two in their time together. (TSB.)

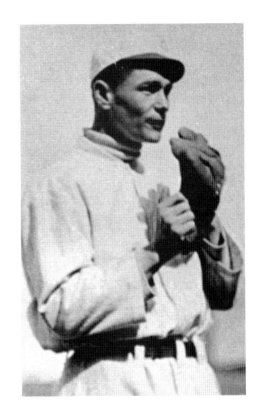

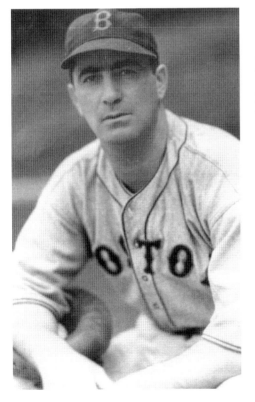

ATHLETE, SCHOLAR, SPY. Performing "splendidly at short" (according to the *Reading Eagle*) but going 0-4 for the Keys against the Robins was Moe Berg (pictured at left), whose .311 average that year enticed the White Sox to purchase his contract for $6,000 at season's end. Eventually moved from shortstop to catcher, it would be Berg's skills behind the plate rather than with the bat (.243 lifetime average) that were the reason for his 15-year major-league career. A graduate of Princeton, Berg spoke a number of languages. He also acted as a spy for the US government prior to and during World War II, including taking photographs of Tokyo during a baseball tour there in 1934. His linguistic and hitting abilities were both addressed when a teammate, told that Berg spoke seven languages, responded, "Yeah, and he can't hit in any of them." (NBHOF.)

May 28, 1928: Philadelphia Phillies 7, Keys 6. The best that can be said of the 1928 Phillies was that, by losing two fewer games than the 1941 Phillies (111 losses), they avoided the distinction of being the worst Phillies team to play in Reading. Phillies catcher Spud Davis (pictured above) was a member of the woeful 1927 Reading Keys, which assembled a 31-game losing streak on its way to a last-place finish. Davis compiled a lifetime average of .308 over a 16-year major-league career, during which he spent eight seasons in baseball purgatory with several dreadful Phillies teams. Starting the 1928 season with the Cardinals (who would win the pennant that season), Davis was traded to the last-place Phillies for Jimmie Wilson (see page 45). Briefly smiled upon by the baseball gods, Davis was traded to the "Gashouse Gang" Cardinals in 1933 for none other than Jimmie Wilson, only to be banished again to the Phillies prior to the 1938 season. At that time, the Phillies were managed by Jimmie Wilson. Returning to the scene of the crime that day, Davis went 0-3. (NBHOF.)

LINKED TO SPUD. Traded twice for Spud Davis, Jimmie Wilson (pictured at right) played for 18 seasons. He managed the Phillies for five seasons, coming to Reading with the team in 1938. Wilson then managed the Cubs for four seasons, having his 1941 Cubs team play in Reading. (NBHOF.)

PINKY OF THE PHILLIES. Rookie Pinky Whitney (pictured at left) went 3-4 with a double and three runs scored against the Keys that day. In Whitney's 12-year career, there would be only one season in which he would not wear a Phillies uniform. (NBHOF.)

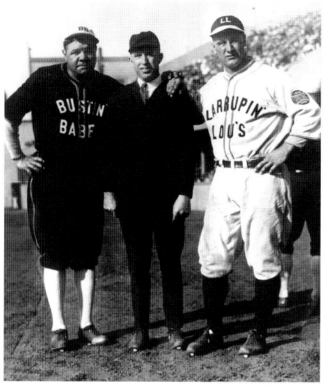

**OCTOBER 20, 1928: BUSTIN' BABES 9,
LARRUPIN LOU'S 8.** Reading would be one
stop on a tour featuring Yankees stars Babe
Ruth and Lou Gehrig (pictured above and at
right), sponsored by Bustin Industrial Products.
At each stop of the tour, a game would be
played between teams, each comprised of
one the Yankee stars plus eight local mortals
(in the words of the *Reading Eagle*, to whom
"nobody paid much attention"). On this day,
Ruth's Bustin' Babes was a team of Reading
policemen, while Gehrig's Larrupin' Lou's was
made up of stars of several local semipro teams.
After hitting a number of memorable shots
out of Lauer's Park during batting practice,
Ruth would be out-homered by Gehrig two
to one during the game, with one of Gehrig's
shots being hit off the Babe after he had taken
the mound later in the game. Although the
Eagle reported a "big crowd" in attendance,
eyewitness accounts put the number at around
500. (Both, NBHOF.)

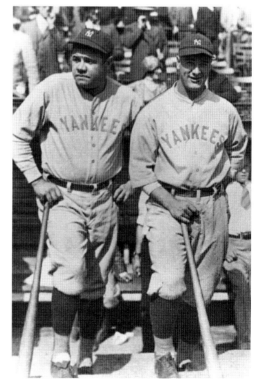

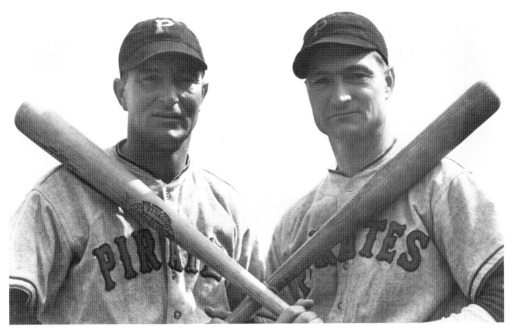

MAY 12, 1929: KEYS 10, PITTSBURGH PIRATES 6. The largest crowd of the season, 7,122, saw a Pirates lineup featuring Paul Waner (HOF, above left) in right field and his brother Lloyd (above right) in center field—"Big Poison" and "Little Poison," respectively—plus third baseman Harold "Pie" Traynor. In support of the Pirates' ultimately unsuccessful effort, Paul, who would hit .336 that year, had three hits, including a double and a triple. Lloyd, who hit .353 that season, had two hits, including a double. Paul's major-league career extended over 20 seasons. He retired with a lifetime average of .333, while Lloyd would play for 18 seasons, compiling a lifetime average of .316. (NBHOF.)

"PIE" TRAYNOR. Banging out a double was Harold "Pie" Traynor (pictured at right), who would hit .356 that season. For most of his 17-year career, Traynor not only was viewed as the best-fielding third baseman in the game, he was also always among the offensive leaders at that position. He compiled a lifetime average of .320 (as opposed to 3.14159.) (NBHOF.)

FAREWELL TO SPECS. Pirates pitcher Lee "Specs" Meadows (pictured at left) gave up four home runs to the Keys, three of which were to Joe Kelly (pictured below), referred to in the *Reading Times* as "Unser Choe." Meadows, a 15-year veteran who won 20 games for the Pirates in 1926 and 19 games both in 1925 and 1927, was the first major-league player to wear glasses. Kelly, who had played two years with the Cubs, had a monster line that day, going four for four with three home runs, a double, and a sacrifice fly plus seven RBI and 16 total bases, having, according to the *Reading Times*, "a perfect day with the willow." Going into the game, Kelly was batting .205. Traded away from the Keys six weeks later, Kelly hit four home runs the rest of the season. Meadows would be released a few days after giving up the home runs to "Unser Choe." Both played a few more years in the minors, but neither would make another appearance in a major-league game. (Left, NBHOF; below, TSB.)

A DIFFERENT KIND OF 1929 CRASH.
Also homering for the Keys in the
midst of a remarkable 1929 season was
outfielder George Quellich (pictured
at right). In addition to batting .347
with 31 home runs and 36 doubles
that year, Quellich would hit safely in
15 consecutive at-bats (also with two
walks), including five home runs. His
last hit in the string was a grand slam.
In the Keys' 1930 exhibition against
Detroit, Quellich hit two home runs.
He played briefly for the Tigers in
1931. (NBHOF.)

POP DIDN'T KNOW BEST. Making the trip with
the Pirates but not at the game was Tremont,
Pennsylvania, native Earl "Sparky" Adams
(pictured at left), who was visiting family in the
area. A member of the 1919 Reading Coal Barons,
Adams was released by manager Charles "Pop"
Kelchner (RHOF) after three games. He found
success at Class D Danville the next season and
was promoted to the Cubs two years later. Adams
would have a 13-year major-league career, playing
several infield positions with a .286 lifetime
average. (NBHOF.)

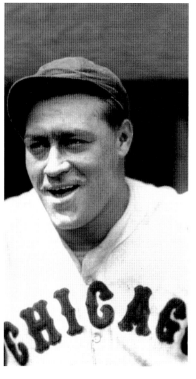

AUGUST 8, 1929: CHICAGO CUBS 6, KEYS 5. Having become a farm team of the Cubs in 1927, the Keys played a five-inning game against the parent club as the second game of a doubleheader (the Keys lost the first game to Toronto) in front of a packed house of 6,175. With four future Hall of Fame members in the lineup and on the way to 98 wins and a pennant, the Cubs, managed by Joe McCarthy (HOF), eked out a narrow win in which the big blow was a three-run home run by Rogers Hornsby (HOF). This was the second time the "Rajah" would homer in Reading (the first coming in 1922). He was on his way to hitting .380 with 39 home runs that season, leading the league with 156 runs scored. In his 23-year playing career, Hornsby (pictured above) hit 301 home runs and had a .358 lifetime average. Lewis Robert "Hack" Wilson (HOF), although blasting a number of balls out of the park during batting practice, would go 0-3 in the game. Wilson (pictured at left) led the league with 156 RBI that season (and was one year short of his 191 RBI season, still the record). But he would not hit a ball out of the infield in this game. (Above, NBHOF; left, TSB.)

KIKI. Despite hitting a career-high .360 that season, Hazen "Kiki" Cuyler (HOF, pictured at right) went 0-3 that day. He was thus unable to show his speed on the base paths, a skill that would result in his leading the league that season with 43 stolen bases. In his 18 big-league seasons, Cuyler hit over .300 ten times, retiring with a .321 lifetime average. (NBHOF.)

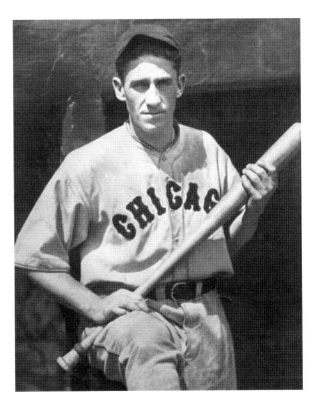

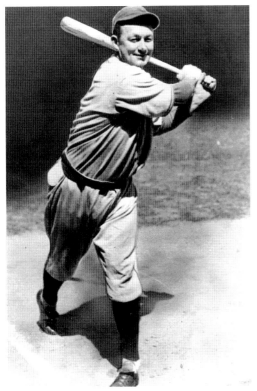

THE YEAR OF THE QUIET GABBY: 1929. Behind the plate for the Cubs that day, driving in a run and going 2-2, was Charles Leo "Gabby" Hartnett (HOF, pictured at left). This appearance in the field was unusual in the 1929 season for Hartnett, as arm troubles limited his play with the Cubs in official games to 25 pinch-hitting and one field appearance. Hartnett recovered the next season, hitting .339 and leading the league in putouts, assists, and runners caught stealing. He played 12 more seasons. (TSB.)

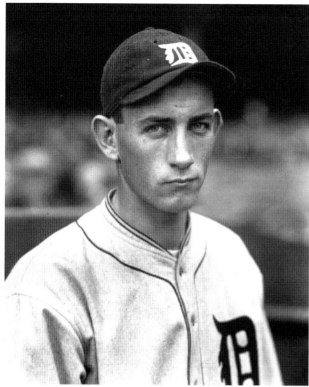

JUNE 18, 1930: KEYS 12, DETROIT TIGERS 7. Under the headline "Reading Club Plays Much Better Ball than Usual with Nothing At Stake," the *Reading Eagle* related how the Keys lost to Toronto by a score of 13-10 in the first game of a doubleheader (taking undisputed possession of last place in the International League). The local club then upset their major-league visitors. Tiger manager and former Reading Pretzel Bucky Harris's second homecoming to Reading—he played in Reading with Washington in 1920—was spoiled by George Quellich's two home runs, leading the Keys' 14-hit assault. Second baseman Charlie Gehringer (HOF, pictured above) led the Detroit attack with two hits and a home run. A Tiger for all of his 19 big-league seasons, Gehringer batted above .300 in 13 seasons, retiring with a lifetime average of .320. In the late innings, Tigers coach Roger Bresnahan (HOF, pictured at right) took over for the team's catcher 15 years after his retirement following a 17-year playing career. In 1907, Bresnahan was the first catcher to wear shin guards. He developed other protective gear, including a batting helmet. (Both, NBHOF.)

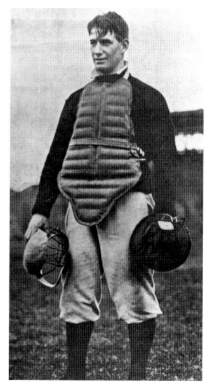

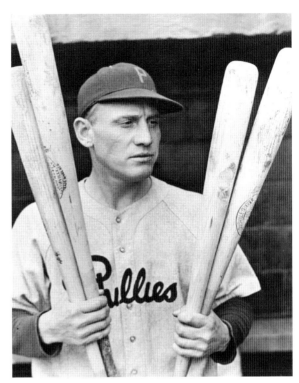

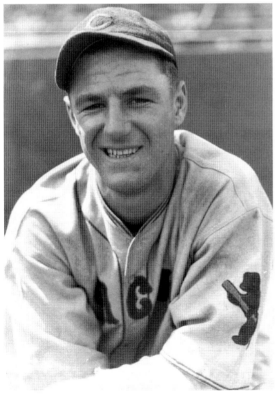

JULY 20, 1930: KEYS 13, PHILADELPHIA PHILLIES 3. In his game account, *Reading Times* sports editor Shandy Hill wrote, "About 2,000 fans lazily wilted in their seats . . .while the tail end teams staged a listless contest." Also wilting that day were Phillies pitchers, who allowed 13 runs on 19 hits. Chuck Klein's (HOF, pictured above) two hits, one a home run, drove in all the visitors' runs. Wearing a Phillies uniform in all but two seasons of his 17-year career, Klein retired with 300 home runs and a .320 lifetime average. As Keys' pitchers held the visitors to three hits, seven Keys had multiple-hit games. Among them was slick-fielding shortstop Billy Jurges (RHOF, pictured at left), in his second year with the Keys. He batted .288 that season. Jurges made his debut with the parent Cubs the next season, the first of a 17-year major-league career. (Both, NBHOF.)

JULY 28, 1930: KEYS 13, PITTSBURGH PIRATES 9. Of a game in which the Pirates committed five errors, *Reading Eagle* sports editor Bill Reedy wrote that the outcome was "insignificant in view of the indifferent playing attitude of the two teams." The Keys' attack was led by Pete Scott, who had three hits, including a home run and three RBI. He spent the 1928 season with the Pirates, during which he hit five home runs, all during a three-game span in Boston. In his sole season with the Keys, Scott (pictured at left) posted remarkable numbers: .349 batting average, 32 home runs, 34 doubles, and 130 RBI. (The 32 home runs stood as a franchise record until 1960.) Scott did not play again in the major leagues. Keys catcher Earl Grace, playing in right field that day, also had three hits, including a home run and two RBI. After hitting .324 for the Keys, Grace (pictured below) was traded to Pittsburgh the next season. Paul Waner not only homered for the Pirates, but pitched two innings, giving up one run on four hits. A curious rehab regimen employed by the Keys involved pitcher Hank Gramp. Making his first appearance in two months following an injury, he pitched the entire game. (Both, TSB.)

IF YOU BUILD IT, SOME OF THEM WILL COME

**APRIL 12, 1931: PHILADELPHIA ATHLETICS
8, KEYS 3.** With the crowd no doubt asking,
"Where's Jimmy Foxx?," the A's, who would win
107 games and the pennant, sent a team to play
the Keys that not only lacks Foxx, Al Simmons,
and Mickey Cochrane, but also any of the team's
starters, other than shortstop Dib Williams.
Reserve first baseman Phil Todt (pictured above)
had three hits, including a triple, to lead the
group of reserves and minor-leaguers. This would
be Todt's only season with the A's and his final
year in the major leagues. The winning pitcher
for the A's was 20-year-old Glenn Liebhardt
(pictured at left), who surrendered three runs in
six innings. The son of former Cleveland Naps
pitcher Glenn Liebhardt, the younger Liebhardt
appeared in five games for the A's in the prior
season. Liebhardt was assigned to the Keys by
the Athletics two weeks after his appearance
in Reading but was returned after a few games.
Over the next seven seasons, he pitched in the
minor leagues, except for two brief stints with
the St. Louis Browns. So, where was Jimmy
Foxx? (Both, TSB.)

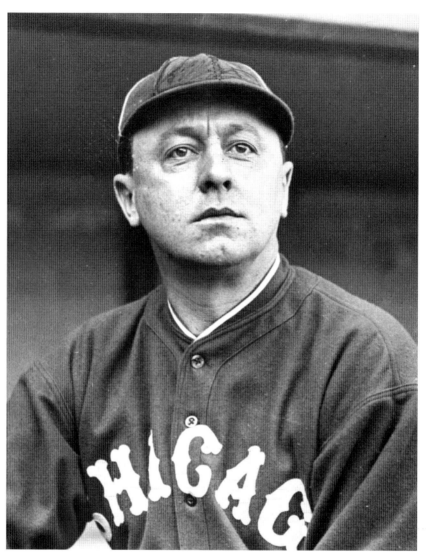

APRIL 5, 1932: PHILADELPHIA PHILLIES 5, KEYS 2. Bob Adams held the Keys to two runs in seven innings, and he got two hits and drove in two runs, leading the Phillies to victory. Appearing as a pinch-hitter for the Keys was their former batboy, 18-year-old Reading native (and future major-leaguer) Dominic Dallesandro (RHOF), who flies out. *Reading Times* sportswriter Ed Hill wrote, "The good folks of Reading . . . failed to put in appearance in any great numbers." The poor gate for this game was an omen for the season. Keys president and manager Clarence "Pants" Rowland (pictured above), having owned the team for a year, initially declared his intention to keep it in Reading, despite his having received offers from a number of larger cities. However, he sought an increase in attendance. The former White Sox manager was awarded a golden horseshoe on opening day—declared "Pants Rowland Day"—by a committee whose motto was "Keep the ball club in Reading." After the Keys drew only 60,000 fans in 61 home dates, Rowland moved the team to Albany in early August, where they finished the season as the Senators. (TSB.)

JULY 5, 1933: BOSTON RED SOX 6, READING RED SOX 3. The new team in Reading for the 1933 season was the Red Sox, of the Class A New York Pennsylvania League. Before only 877 spectators, the visitors pounded out 17 hits, with seven Bostonians having multi-hit games. Although Reading native Dom Dallesandro (pictured at right) went 0-3 for the home team, the *Reading Times* reported that he "disported himself . . . by snaring three line drives that were labelled hits." "Dim Dom" would hit .323 that season for Reading. Prompted by the small gate, *Reading Eagle* sports editor Bill Reedy wrote: "When the Boston Red Sox can't attract at least 1,000 people, it is doubtful in my mind whether any sport attraction can fare well in this city at this time." Reedy might have added that the song "Buddy, Can You Spare a Dime?" applied to the business of sports as much as it did to any other facet of American life at that time. (NBHOF.)

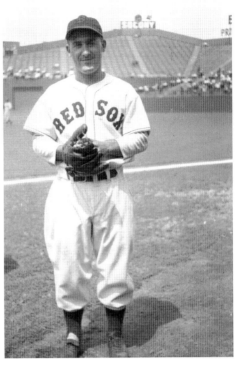

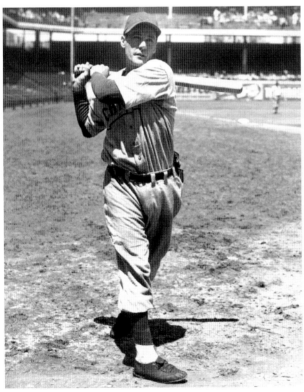

AUGUST 6, 1934: BOSTON RED SOX 8, READING RED SOX 4. Former Reading Pretzel Bucky Harris had his third Reading homecoming, this time as manager of the visiting Boston Red Sox. Boston put the game away with a five-run rally in the ninth inning. Although the home crowd of 2,000 was more than twice as large as it was for the last Boston game in Reading, it was far from great, symptomatic of the attendance that year. The Reading Red Sox left town when the season ended. In the home team's lineup was 18-year-old Phil Cavaretta (RHOF, pictured at left), who went 1-3 with one run and one RBI. Cavaretta played 22 big-league seasons, 20 with the Cubs. (NBHOF.)

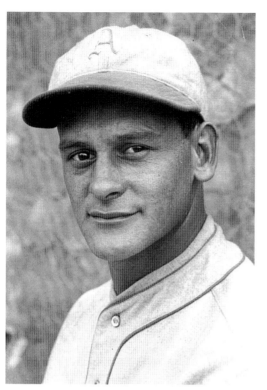

AUGUST 2, 1937: PHILADELPHIA ATHLETICS 7, BERKS ALL-STARS 3. Now in its third season without a minor-league team, Reading hosted Connie Mack and the A's, who played a squad of all-stars from local teams before 5,300 fans. At a pregame luncheon, Mack pleased the Reading fans, vowing to help bring "baseball back to Reading." Getting two hits in the A's 13-hit attack was Robert "Indian Bob" Johnson (pictured at left), who spent 10 years of his 13-year career with the Athletics. Hitting over 20 home runs in each of the first nine years with the A's and over .300 five times, Johnson retired with a .296 lifetime average and 288 home runs. (NBHOF.)

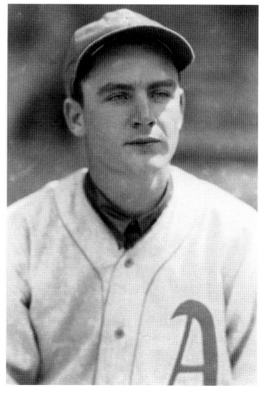

GEORGE DOES IT ALL. The star of the game was Athletics pitcher George Turbeville (pictured at right), who threw a complete game, hit a double and a home run, and drove in two runs. His final major-league game was a few weeks later, when, over two innings in a game against the Yankees, Turbeville gave up two runs and five walks. In 1936, Turbeville had the distinction of giving up Joe DiMaggio's first big-league home run. (TSB.)

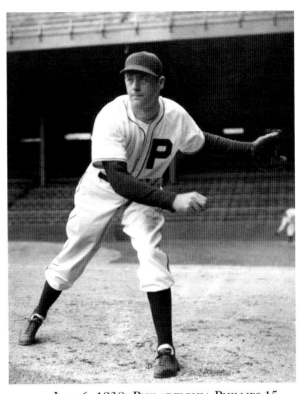

JULY 6, 1938: PHILADELPHIA PHILLIES 15, LEGION ALL-STARS 5. As bad as the 1938 Phillies were (eighth place, 45 wins), they still managed to overwhelm a group of Berks County American Legion all-stars. Pitching the first inning for the Phillies was Hugh "LP" Mulcahey (pictured above). The "LP" stood for "Losing Pitcher," as Mulcahey's record that season was 10-20, proportionally consistent with his 45-89 career record. During his nine-year career, he twice led the league in losses. An alumni of the 1934 Reading Red Sox, Mulcahey had the distinction of being the first major-league player to be drafted during World War II. The photograph at left captures the conclusion of a 1939 mound conference involving Phillies manager Doc Prothro (left), Mulcahey (center), and catcher Spud Davis. Davis's body language exhibits more than a hint of frustration in what was undoubtedly a recurring scene over several seasons. (Both, NBHOF.)

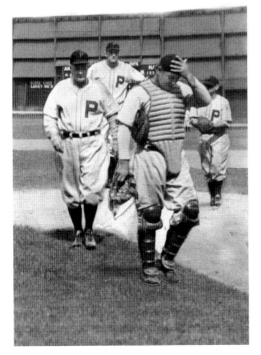

MacPhail Comes to Reading. Following the Brooklyn Dodgers' December 1940 purchase of the Reading Chicks of the Interstate League, the Dodgers president and general manager, Larry MacPhail (HOF, pictured at left), hired his 24-year-old son Lee MacPhail Jr. as the business manager of the team. To boost attendance for the renamed Brooks, Lee arranged for five different major-league teams to play games in Reading. The paid attendance for the games with the major-leaguers totaled $21,000, increasing the Brooks' gate for 63 home dates to $61,000. Without the gate for the five exhibition games, the season would have been a financial disaster. (NBHOF.)

The MacPhails, Baseball Royalty. Lee MacPhail (HOF, pictured at right) left the Brooks after that season to serve in the Navy. The position with the Brooks, though, was the beginning of a 40-year career in baseball, which included front office positions first with the Yankees, then the Orioles, followed by his serving as American League president, then as president of the Players Relation Committee. Lee's plaque in Cooperstown states how he and Larry "form the first father-son tandem in the Hall of Fame." Lee's son Lee MacPhail III was appointed general manager of the Reading Phillies in 1969 but tragically was killed in a traffic accident a few months later. Lee's son Andy, recently named president of the Phillies, was successful in front office positions he held previously with the Twins, Cubs, and Orioles. (NBHOF.)

IF YOU BUILD IT, SOME OF THEM WILL COME

THE SKOOJ IN THE BROOKS' CROWN. The Dodgers' purchase of the Reading Chicks included its 20 players, plus two sets of uniforms. What would prove to be the most valuable asset acquired was the contract of Carl Furillo (RHOF, pictured at right), a native of nearby Stoney Creek Mills who became known as "The Reading Rifle." (Furillo's nickname was "Skooj" after an Italian seafood dish he was fond of—*scungilli*, made from an aquatic snail.) After he batted .319 in Class D ball for most of the 1940 season, Furillo's contract was transferred to the Chicks, where he batted .320 in 25 at-bats. Furillo proved to be worth the acquisition, batting .313 for the Brooks in 1941, with 25 assists. Following three years in the Army, in 1946 Furillo began a 15-year big-league career, all of which were spent with the Dodgers—and most of which were spent as the right fielder on the team of "Bums" that would win seven pennants and two World Series. Winning the 1953 NL batting crown with a .344 average, Furillo retired with a lifetime average of .299. (NBHOF.)

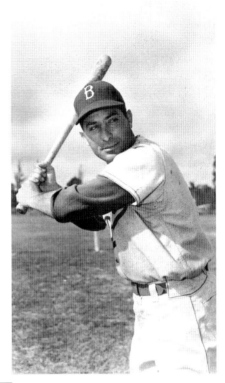

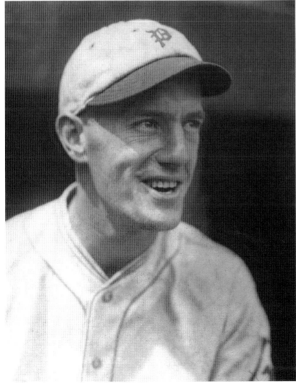

FUTURE DODGERS BRAIN TRUST. The Brooks had a good young team, including a number of players returning from the team that finished in first place the year before. Managing them was Fresco Thompson (pictured at left), who, during his nine-year career in the majors, played with the Phillies, Dodgers, Pirates, and Giants. (He appeared in exhibition games in Reading with the Phillies in 1928 and 1930.) After managing in the Dodgers farm system for several years, Thompson became an executive in the team's front office, running minor-league operations. He was eventually named the Dodgers' executive vice president and general manager. (NBHOF.)

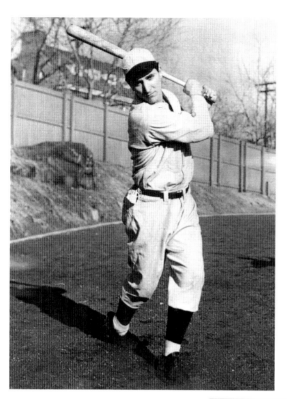

FUTURE DODGERS BRAIN TRUST II. The Brooks second baseman, Al Campanis (pictured at left), played briefly with the parent club in 1943, but otherwise spent seven seasons in the Dodgers minor-league system. Following a brief time as a scout, the graduate of New York University joined the team's front office. Becoming general manager in 1968, Campanis would hold the position until being fired in 1987 for controversial remarks about race made in a television interview. (NBHOF.)

JULY 11, 1941: PITTSBURGH PIRATES 8, READING BROOKS 3. Pirates coach Mike Kelly stepped in for manager Frankie Frisch, who took the night off, and created what the *Reading Eagle* described as "a hectic evening for the official scorer and newspapermen" when he freely makes substitutions but fails to report them. Pirates shortstop Arky Vaughn (HOF, pictured at right) had one of 10 of the team's hits. Vaughn spent 10 of his 14 big-league seasons with the Pirates, hitting over .300 twelve times. He retired with a lifetime average of .316. The gate for the game was a healthy 3,127. (NBHOF.)

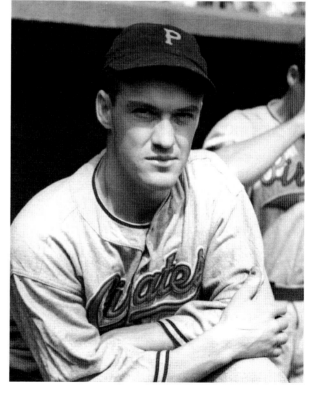

IF YOU BUILD IT, SOME OF THEM WILL COME

JULY 28, 1941: READING BROOKS 5, PHILADELPHIA ATHLETICS 2. Baseball commissioner Kennesaw Mountain Landis found that A's broadcasts on local radio stations in Reading during Brooks games violated baseball rules. As compensation, Connie Mack agreed to bring the A's to Reading, with the Brooks keeping the entire gate. The 6,000 fans attending the game was the largest crowd at Lauer's Park in years. The game was halted by rain after seven innings, with the Athletics mustering only four hits. Suffering from lack of support was A's pitcher Pat Tobin (pictured at right), three weeks away from his only big-league appearance. On August 21, he gave up four runs in one inning to the Browns, leaving him with a career ERA of 36.00. (TSB.)

MOSES IN THE WILDERNESS. Going 0-1 that day was fan favorite Wally Moses (pictured at left), who valiantly toiled for 10 seasons in front of Philadelphia fans, hitting above .300 in each of the first seven years of his career as a member of A's teams that would finish last or next to last. A Philadelphia baseball icon, Moses, at the conclusion of his 17 major-league seasons as a player, served as a coach and hitting instructor with the A's and then the Phillies. (NBHOF.)

AUGUST 5, 1941: READING BROOKS 8, BROOKLYN DODGERS 3. Before 5,300 fans, the pennant-bound Dodgers, who would win 100 games that season, scrounged seven hits from a starting lineup featuring three future Hall of Famers: shortstop Pee Wee Reese (0-3), second baseman Billy Herman (0-1), and left fielder Joe Medwick (2-4, RBI). Rested that night were both Pete Reiser (who would win the 1941 NL batting title), and Dolph Camilli (who would win the 1941 NL home run and RBI titles). Pictured above is a depressed looking Dodger president Larry MacPhail, who came from New York expressly to see his Dodgers win. Next to him, trying to be gracious, is his daughter-in-law Jane MacPhail. Lee MacPhail took great pleasure in beating his father's team and especially Dodger's manager Leo Durocher (HOF), who MacPhail had to hound to bring the team to Reading. Both MacPhails were disappointed that the last place A's outdrew the first place Dodgers. Famous for the quote "Nice guys finish last," on this occasion, Durocher (pictured at right) would indeed be a nice guy, subbing for Reese at shortstop in the late innings to give him a rest. (Above, *Reading Eagle* files; right, TSB.)

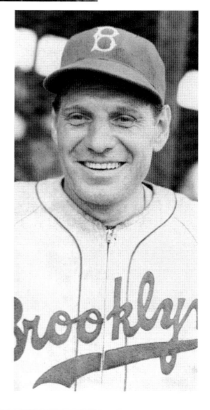

IF YOU BUILD IT, SOME OF THEM WILL COME

HOF Up the Middle. The Dodgers hall-of-fame combination of Pee Wee Reese (pictured at right) at shortstop and Billy Herman (pictured below) at second went 0-4 in front of the Reading fans that evening. Reese, only in his second year, played the entire season with a brace on his ankle as a result of a broken heel suffered the year before. Although he hit only .229 that season, far below the .269 average he would compile in his 16 big-league seasons (all with the Dodgers), he gamely appeared in 152 games, fielding the highest number of chances (866) with the highest number of assists of any year in his career. Acquired from the Cubs earlier that season, Herman's excellent play in the field and .291 average were important factors in Brooklyn winning its first pennant since 1920. In 15 big-league seasons, Herman compiled a lifetime average of .304, hitting over .300 in nine seasons and being named to the all-star team 10 times. (Right, NBHOF; below, TSB.)

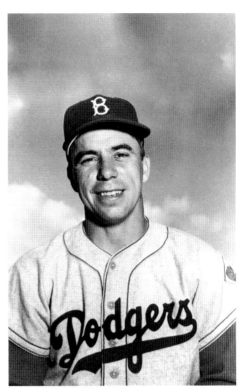

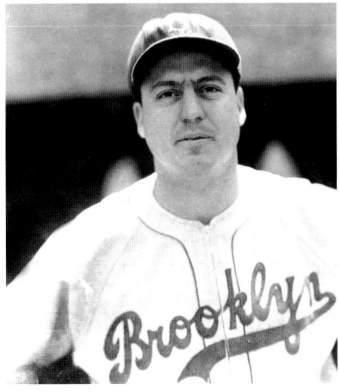

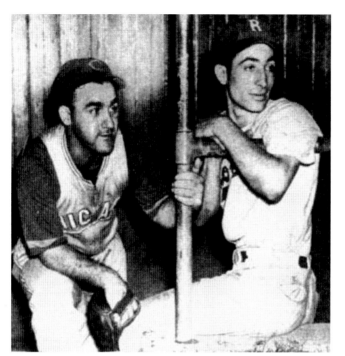

AUGUST 25, 1941: CHICAGO CUBS 5, READING BROOKS 2. On "Dominic Dallesandro Night," 3,500 fans welcomed back a local baseball hero. The guest of honor (left) pleased the crowd by hitting a single in his first at-bat. Shown here chatting before the game with Carl Furillo (right), another Reading-area native with a major-league future, Dallesandro, a former Keys batboy and member of the 1933 and 1934 Reading Red Sox, played another six seasons with the Cubs. (*Reading Eagle* files.)

SWISH. Another former member of the 1934 Reading Red Sox, Phil Caveretta led the Cubs' attack with two home runs. He was described by the *Reading Times* as "a one man wrecking crew." Also homering for the Cubs was Bill "Swish" Nicholson ("Big Bill" to Cub fans), replaced late in the game by Cubs coach Kiki Cuyler (HOF). Nicholson (pictured at right) played the last five years of his career with the Phillies, giving their fans the chance to chant "swish, swish, swish" as he took his practice swings at the plate. (NBHOF.)

IF YOU BUILD IT, SOME OF THEM WILL COME

AUGUST 30, 1941: PHILADELPHIA PHILLIES 10, READING BROOKS 1. On the way to their fourth last-place finish in what would be a five-year streak, the Phillies pound a tired Brooks pitching staff for 15 hits. Played before a so-so crowed of 1,700, the game was the second of a doubleheader (the Brooks defeated Trenton in the first game, 13-7). Doc Prothro, who managed the Phillies to three last-place finishes, takes the day off as coach Hans Lobert (pictured above) manages. After serving eight years as a coach, Lobert managed the 1942 Phillies to a last-place finish in his sole season at the helm. Phillies first baseman and Villanova graduate Nick Etten (pictured at left) went 4-5 with two doubles. That season, Etten's .311 average and 79 RBI were team highs. Over a nine-year major-league career, Etten spent two years with the A's, three with the Phillies, and four with the Yankees. He then played three more years in the minors, slugging 43 home runs for Oakland of the Pacific Coast League in 1948. The highlight of the evening for the home team was that Carl Furillo was awarded a new suit between games as the most popular Brook. At least Skooj got new duds. (Both, NBHOF.)

DAY OF THE DANNIES. Native Pennsylvanians Danny Litwhiler (pictured at left) from Ringtown homered, had three RBI, and scored a run, while Phillies rookie Danny Murtaugh (pictured below) from Chester had two hits with a double and three RBI and one run scored. After three more seasons with the Phillies, Murtaugh would go west (while he was still a young man), playing five years, coaching two years, and then managing for 15 years. Murtaugh would lead the Pirates to four division titles, two pennants, and two world championships. Litwhiler came on like gangbusters for the 1940 Phillies, batting .345 in 36 games, and would lead the team with 18 home runs in 1941. Traded by the Phillies to the Cardinals on June 1, 1943, he would leave a team that finished last in each of his seasons there and instead play on a pennant winner. Following his 11-year big-league career, the Bloomsburg University graduate successful tenures as baseball coach at Florida State and then at Michigan State. He invented or developed more than 100 devices relating to baseball and coaching. (Both, NBHOF.)

IF YOU BUILD IT, SOME OF THEM WILL COME

LET GEORGE FIELD DO IT

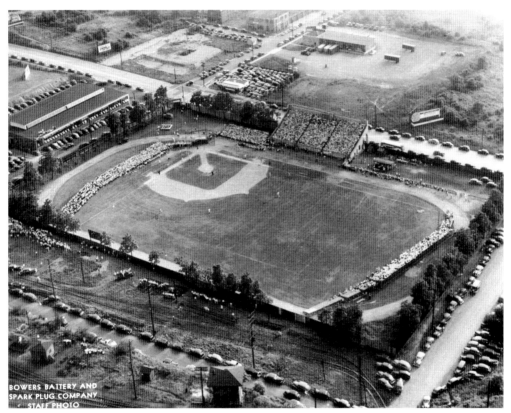

LET GEORGE FIELD DO IT. With the demolition of the dilapidated Lauer's Park in 1943, the only suitable site for ball games in front of large crowds was George Field, which had a maximum capacity of about 3,300. This park hosted three exhibition games. This aerial photograph was taken from a private airplane during the Cardinals game against the Bowers Battery team in 1946. (Reading Fightins' files.)

AUGUST 24, 1944: BROOKLYN DODGERS 7, CARTECH STEELIES 5. Charlie Dressen managed the Dodgers in place of Leo Durocher, who, according to the *Reading Times*, was "detained in New York on business." Against a recreation league team, the visitors racked up 15 hits, including a single by "The People's Cherce" Dixie Walker, who would lead the league that year with a .357 average. Adding a double to the Dodgers attack was 38-year-old player-coach Lloyd Waner (HOF). Dodgers starter Hal Gregg (pictured at left) pitched the entire game, odd not only because major-league teams usually rested pitchers from their regular rotation in exhibition games, but also because Gregg threw more innings than anyone else on the Dodgers staff that season. Dodgers backup catcher Bobby Bragan (pictured below) went 0-4 in his last visit to Reading with the 1941 Phillies, homered as a late inning substitute for Mickey Owen. Following a seven-year major-league playing career, Bragan began a long career as a manager and executive both at the major- and minor-league levels, including stints as manager of the Pirates, Indians, and Braves. (Both, NBOHF.)

LET GEORGE FIELD DO IT

September 15, 1944: Philadelphia A's 7, Parish Steelies 1. Before 3,000 fans in the packed George Field, the Athletics accumulated 14 hits and exploded for six runs in the fifth inning against another recreation league team. Leading the attack with three hits each were 42-year-old player-coach Al Simmons (HOF, pictured at right) and first baseman Bill McGhee. Over a 20-year career, Simmons would collect 2,927 hits with a lifetime average of .334. (NBHOF.)

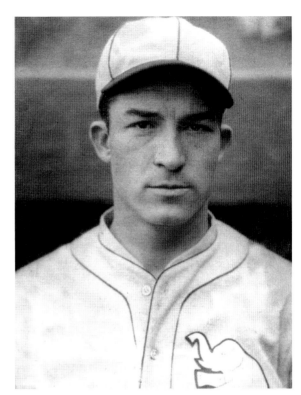

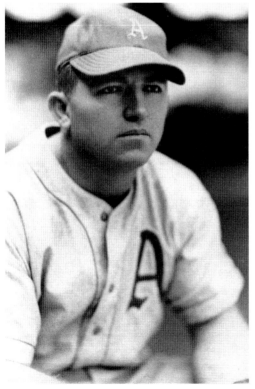

Thirty-Five-Year-Old Rookie. An example of a "wartime ballplayer" was Bill McGhee (pictured at left), who spent the 1944 and 1945 seasons with the Athletics, averaging a respectable .272, with one home run and 38 RBI. McGhee's other 21 seasons of professional baseball were spent with 21 different minor-league teams, compiling a lifetime minor-league average of .321. Released by the A's after the 1945 season, McGhee played in the minor leagues until 1957. (TSB.)

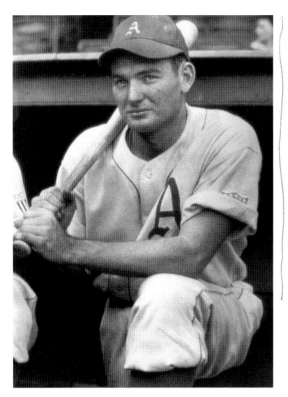

FOR BARNEY WHO? Contributing a double to the A's attack was 21-year-old George Kell (HOF, pictured at left). Promoted to the A's after burning up the Class B Interstate League while playing for their affiliate, the Lancaster Red Roses, Kell held down third base for the A's in 1944 and 1945. Traded to the Tigers for Barney McCoskey early in the 1946 season (in one of the A's all-time worst deals), Kell was told by Connie Mack, "I'm sending you to a team that will pay you the kind of money that I can't." Kell hit over .300 nine times in his 15 big-league seasons, with a lifetime average of .306. (TSB.)

IT WAS THAT FIFTH INNING. Holding the A's to one run over the first four innings for Parish was Robesonia, Pennsylvania, native Stan "Betz" Klopp, who had pitched for the Boston Braves that season as recently as August 5. Having pitched for several seasons in the Dodgers system, Klopp (pictured at right) was signed by the Braves in June as a 33-year-old rookie, appearing in 46 games, all in relief, and returning home when the Braves sent him to the minor leagues. The A's were shut out the final four innings of the game by 17-year-old Wernersville native Harold "Hal" Boyer. (Charles J. Adams III Collection.)

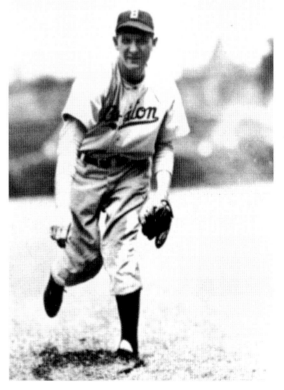

LET GEORGE FIELD DO IT

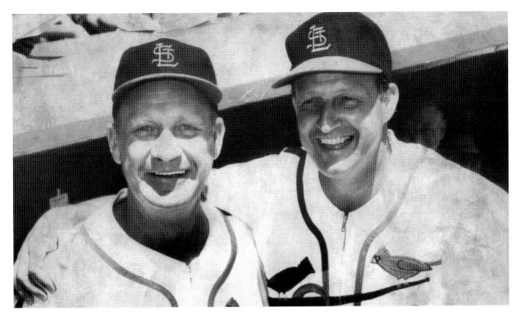

AUGUST 5, 1946: ST. LOUIS CARDINALS 12, BOWERS BATTERY 1. On their way to the 1946 world championship, the Cardinals stopped in Reading to play a local company team in a game scheduled as a testimonial by the people of Reading to native son—St. Louis third baseman George "Whitey" Kurowski (RHOF, pictured above left). In addition to collecting two hits and three RBI, the guest of honor (referred to in the *Reading Times* as "The Pounding Pole") received a $600 bond, golf bag, travelling bag, key case, wallet, and season pass to a local movie house. Stan "The Man" Musial (HOF, pictured above right and below), playing first base, contributed a hit and run scored in the Cardinals 21-hit assault. His .365 average would lead the NL that season, as would his totals in hits, doubles, triples, runs scored, and total bases. Compiling a .331 lifetime average, Musial would drive in more than 100 runs 10 times during his career. (Both, NBOHF.)

MAD DASH. Right fielder Enos Slaughter (HOF, pictured at left) and second baseman Red Schoendienst (HOF) each contributed a single in the Cardinals attack. In pregame batting practice, Slaughter and Musial both launched a number of shots over the right field wall in tiny George Field, much to the delight of the crowed. Slaughter's 18 home runs that season led the team, and his 130 RBI was tops in the league. Slaughter hit above .300 in 10 of his 19 big-league seasons. He is best remembered for his "Mad Dash" in the Cardinals' Game 7 victory over the Red Sox in the 1946 World Series, scoring what proved to be the winning run. With two outs in the bottom of the eighth inning and the score tied, he scored from first base on a single by Harry Walker. (TSB.)

RED'S NEW POSITION. In 1946, Red Schoendienst (HOF, pictured at right) had a healthy .281 batting average, but it would be his play in his new position of second base (moving from left field) that made his reputation. He led the league in fielding percentage, the first of six times he accomplished this feat. Over a 19-season career, Schoendienst batted above .300 seven times and was elected to 10 all-star teams. On a show business note, future *Today* host Joe Garagiola caught half the game for the Cardinals. (TSB.)

LET GEORGE FIELD DO IT

IF YOU BUILD IT,
MAYBE SOMEONE WILL
MOVE A TEAM HERE

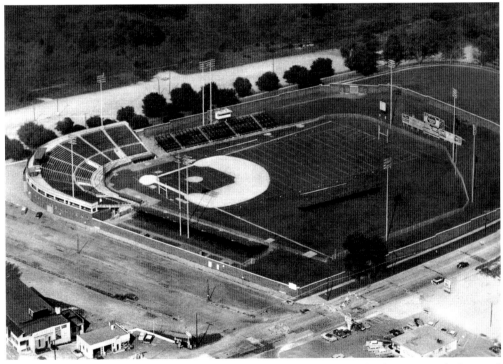

IF WE BUILD IT, A TEAM MAY COME. In 1951, the City of Reading built Municipal Memorial Stadium without a minor-league tenant. Obligingly, Cleveland moved its team in the Class A Eastern League from Scranton to Reading, where it began play for the 1952 season. Now named First Energy Stadium, it has been the home park of the Reading Fightins (formerly Reading Phillies) since 1967. It sports a number of improvements since the time of this photograph in 1952, including a roof over the grandstand, a pool, picnic areas, a left field beer deck, and a food court. (Reading Fightins' files.)

OCTOBER 15, 1951: DANNY LITWHILER ALL-STARS 11, MINOR-LEAGUERS 4. A crowd of 1,500 attended the first game played by professionals at the new stadium, where team of major-leaguers, organized by Danny Litwhiler of the Reds, defeated a local team of current and former minor-leaguers managed by Whitey Kurowski (RHOF). Among the major-leaguers are Nellie Fox (HOF, pictured at left) of the White Sox, Carl Furillo of the Dodgers, and Sibby Sisti of the Braves. Former Boston Brave Betz Klopp of Robesonia pitched two innings for the minor-leaguers. Fox had a single with two runs scored, coming off a season in which he batted .313 and was named starting second baseman on the all-star team. Originally with the A's, in 1949 Fox was traded to the White Sox for catcher Joe Tipton in one of Connie's worst deals. Excelling in the field over his 19-year career, Fox would bat above .300 six times. Sebastian "Sibby" Sisti (pictured below) had two hits and drove in two runs for the major-leaguers. A true utility man, Sisti played every position except pitcher and catcher over his 13 big-league seasons, spent entirely in the Braves organization. (Both, NBOHF.)

JUNE 9, 1952: CLEVELAND INDIANS 8,
READING INDIANS 1. A crowd of 6,300 saw
the new team in town, the Reading Indians,
Cleveland's affiliate in the Class A Eastern
League, play its parent club. Cleveland was led
by manager Al Lopez (HOF, pictured at right).
Aside from this game, Cleveland would play
Reading in each of the next three seasons,
during which time they would win one
pennant (1954) and finish second behind the
Yankees three times. In center field that night
was Larry Doby (HOF, pictured below), the
first African American to play in the AL. His
debut was three months after that of Jackie
Robinson in the NL. Leading the league with
32 home runs in 1952 and again with 32 in
1954, Doby was selected to the all-star team
seven years in a row. Replacing Doby in center
field late in the game was former Dodger star
Pete Reiser, in the final year of his career.
(Both, NBOHF.)

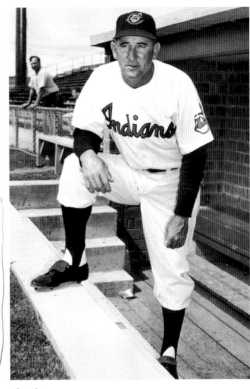

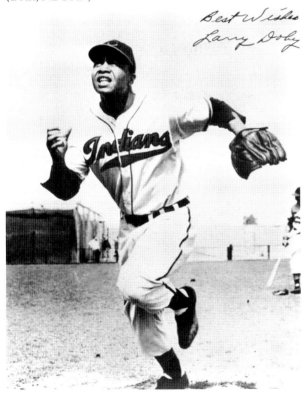

Best Wishes
Larry Doby

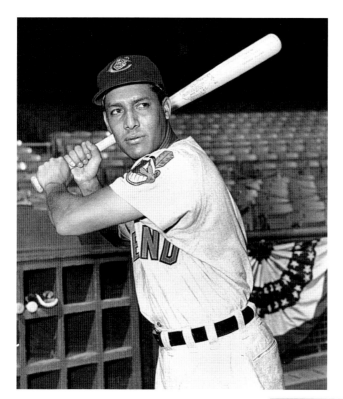

NOT TONIGHT. Anchoring the Indians infield at second base for most of the 1950s was Bobby Avila (pictured at left), whose slick fielding and steady bat led to three all-star selections. Avila led the league in batting in 1954 with a .341 average, but he went 0-2 against Reading in this game. (NBOHF.)

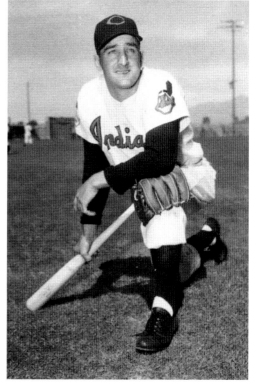

TONIGHT'S THE NIGHT. Having a successful evening was Cleveland reserve outfielder Jim Fridley (pictured at right), in his only year with the Indians. He powered the visitors' attack with three hits, a home run, and four RBI. Fridley would also play with the Orioles and briefly with the Reds. He was one of the 17 players involved in a 1954 trade with the Yankees, including Bob Turley, Don Larsen, Hal Smith, and Gus Triandos. (TSB.)

May 18, 1953: Reading Indians 4, Cleveland Indians 3 (12 innings). In only the second exhibition game in Reading to go into extra innings rather than being declared a tie, Reading won in front of a crowd of 4,280, as Joe Altobelli (RHOF) scored in the bottom of the 12th on a wild pitch. (The 1953 Indians are also in the RHOF.) In the four games that Cleveland played in Reading, no member of its famed rotation of Early Wynn (HOF), Bob Lemon (HOF), Bob Feller (HOF), Mike Garcia, or Herb Score appeared. (*Reading Eagle.*)

One for the Books

CLEVELAND	ab	r	h	o	a		READING	ab	r	h	o
St'l'nd ss	6	0	2	2	4		Graber cf	6	0	1	5
Av'la 2b	2	0	1	3	1		Reg'do 2b	5	1	1	1
Doby cf	2	0	0	1	0		Alto'll 1b	4	2	2	12
M'J'ski 3b	5	0	0	2	3		H'rrell 3b	6	0	1	0
M'chell lf	2	0	0	1	0		J.King lf	5	0	1	1
S'pson rf	2	0	0	0	0		C'ovito rf	1	0	0	7
Glynn 1b	5	1	1	14	0		Seaone c	2	0	1	4
A'ward c	2	1	1	2	2		M'g'ry ss	5	0	0	3
Ch'k'les p	1	0	0	0	1		D'vld'n p	2	1	1	0
Aber p	2	0	0	2	5		R.King c	2	0	0	3
Ken'dy 3b	3	0	0	4			G'm'ael p	1	0	0	0
J.L'm'n lf	3	1	1	3	0						
M'C'ky rf	3	0	1	0	0						
Foyles c	3	0	1	4	1						
W'lake cf	2	0	0	1	0						

Totals 43 3 8 a35 21 Totals 39 4 8 36 1
a-Two out when winning run scored.

CLEVELAND 000 012 000 000—
READING 003 000 000 001—

E — Davidson, Strickland, Carmichael, Foyles. RBI—Regalado, J. King 2, Ayward, Foyles 2. 2B—Davidson, Altobelli. 3B—Foyles. HR—Aylward. S—Carmichael, R. King. DP—Aylward and Glynn; Majeski, Strickland and Glynn. Left—Cleveland 10, Reading 11. BB—Davidson 4, Chakales 2, Aber 6, Carmichael 3. SO—Davidson 3, Chakales 1, Aber 3, Carmichael 3. HBP—Aber (Altobelli). HO—Chakales 3 in 3, Aber 3 in 8⅔, Davidson 7 in 6, Carmichael 1 in 6. WP—Aber. W—Carmichael. L—Aber. T—3:10. U—Doyle and Ganakas. A—4,280.

Invisible Star. Having the night off was Cleveland third baseman Al Rosen (pictured at left), on his way to an MVP season in which he led the league with 43 home runs and 145 RBI. He missed winning the batting title (and the Triple Crown) by .001. Rosen appeared in two of the four Cleveland games in Reading, going hitless in four at-bats. Because of injuries, Rosen retired after the 1956 season. Following his playing career, Rosen worked in the front offices of the Yankees, Astros, and Giants, where he was named Major League Executive of the Year in 1987. (NBOHF.)

POWERHOUSE. The 1953 Reading Indians, who would win a league record 101 games, had 12 future major-leaguers on the team: Joe Altobelli, Brooks Lawrence, Billy Harrell (RHOF, pictured at left), Rocky Colavito (RHOF), Herb Score, Rudy Regulado, Joe Caffie, Earl Averill Jr., Bud Daley, Gordie Coleman, Doug Hansen, and Rob Graber. Reading manager Kerby Farrell led Cleveland in 1957. Harrell was the Eastern League MVP, hitting .330, while Colavito (pictured below) led the league in home runs (28) and RBI (121). Harrell played briefly with several major-league teams over a 15-year career. Colavito hit 42 home runs with Cleveland in 1959, when the squad won the AL championship. Then, two days before opening day of the next season, he was dealt by "Trader" Frank Lane to Detroit for 1959 AL batting champ Harvey Kuenn. The city of Cleveland has been subject to the "Curse of Rocky Colavito" ever since. (Left, TSB; below, NBHOF.)

JUNE 7, 1954: CLEVELAND INDIANS 11, READING INDIANS 4. In front of a large crowd of 4,290, the pennant-bound Indians, on their way to 111 victories, exploded for six runs in the seventh inning and put the game away. In what the *Reading Eagle* called a "Parental Pasting," the Cleveland attack was led by Dale Mitchell (pictured at right), who went 2-3 with two runs scored and two RBI. (Mitchell was two years away from his date with destiny as the last out in Don Larsen's 1956 perfect game.) In the photograph below, Vic Wertz (RHOF), who starred in baseball at Reading High School and for the Gregg Post Reading American Legion team, signs autographs. In the game, he went 0-2. Wertz was close to his own date with baseball destiny, when his towering drive was turned into a long out by Willie Mays in Game 1 of the 1954 World Series. (Right, TSB; below, *Reading Eagle* files.)

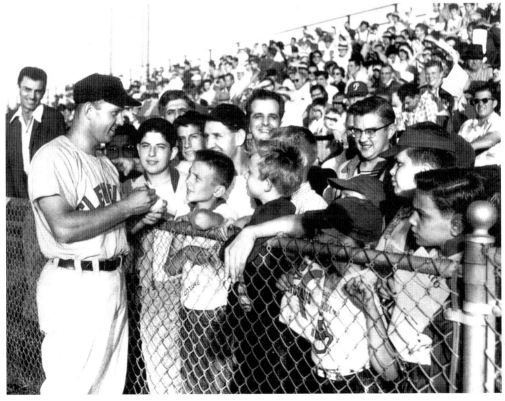

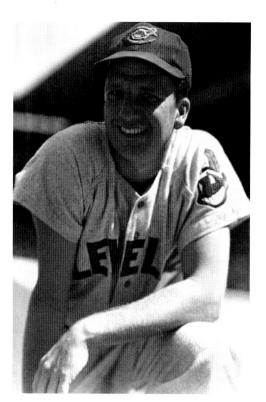

JUNE 20, 1955: CLEVELAND INDIANS 5, READING INDIANS 4. Ralph Kiner (HOF, pictured at left), in the final year of his 10-year career, had two hits, including a homer. Reading outfielder Carroll Hardy, playing in his first game in professional baseball, took an extra-base hit away from Kiner with a diving catch at the center-field fence. (TSB.)

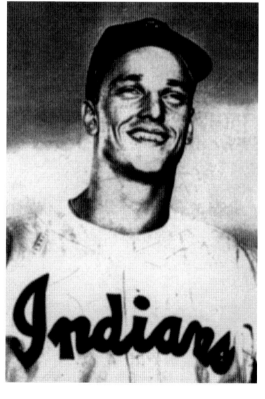

MARIS GOES HITLESS. Roger Maris (RHOF, pictured at right) went 0-2 for Reading. While leading the Reading Indians that season with 19 home runs, he would hit more with the Yankees a few years later (in 1961 setting a record of 61 home runs in one season that would stand for 27 years). The gate was 3,734, and Cleveland would play no more Reading exhibitions, although the Reading Indians would play in Reading until the end of the 1961 season, then again in 1965. (Historical Society of Berks County.)

APRIL 12, 1964: CHICAGO CUBS 6, BOSTON RED SOX 3. The Reading Red Sox was the city's new entry in to the Class AA Eastern League. Its parent club, the Boston Red Sox, hosted the Chicago Cubs in a second "Clash of the Titans"— the second time two major-league teams played in Reading. Before a crowd of 5,780 (Reading's entire gate that season would be 51,120), the Cubs won 6-3 in a game that featured six future Hall of Fame members in the combined starting lineups: Carl Yastrzemski, Dick Williams, Ernie Banks, Billy Williams, Ron Santo, and Lou Brock. (*Reading Eagle* files.)

CHICAGO (N)					BOSTON				
	ab	r	h	bi		ab	r	h	bi
Stewart 2b	3	1	0	0	Schil'ng 2b	2	0	0	0
Brock rf	4	0	0	0	Jones 2b	1	0	1	0
Burton rf	0	0	0	0	Bresso'd ss	2	0	1	0
W.Willi's lf	3	1	0	0	Yastrz'ki lf	3	0	0	0
Landr'm lf	0	0	0	0	Mejias lf	2	0	0	0
Santo 3b	3	1	1	0	Malzone 3b	3	0	2	0
Burke 3b	1	0	0	0	R.Willi's 3b	1	0	0	0
Banks 1b	4	1	1	3	Stuart 1b	5	1	2	1
Rodgers ss	3	0	0	0	Clinton rf	4	1	3	0
Amalf'o 2b	1	0	0	0	Conigli'o cf	4	1	1	0
Cowan cf	4	1	2	2	Nixon c	4	0	0	0
Schaffer c	4	0	0	0	Morehe'd p	2	0	0	0
Ellsw'th p	0	0	0	0	Connolly p	0	0	0	0
a-Gregory	1	1	1	0	Heffner p	0	0	0	0
Hobbie p	1	0	0	0	b-Tillman	1	0	0	1
Buhl p	1	0	0	0	Earley p	0	0	0	0
Schurr p	0	0	0	0					
Totals	33	6	5	5	**Totals**	36	3	11	3

a-Singled for Ellsworth in 5th.
b-Hit sacrifice fly for Heffner in 8th.

Chicago	000 110 001—6
Boston	000 001 020—3

E—Bressoud. PO-A—Chicago (27-8), Boston (27-3). DP—Bressoud, Schilling and Stuart. LOB—Chicago 4, Boston 11. 2B — Clinton. HR — Banks, Stuart, Cowan. SB—Stewart. SF—Tillman.

	IP	R	H	ER	BB	SO
Ellsworth (W)	4	5	0	0	2	2
Hobbie	2	2	1	1	1	2
Buhl	2	4	2	2	1	1
Schurr	1	0	0	0	0	1
Moorehead (L)	5	4	5	1	4	3
Connolly	2	0	0	0	0	0
Heffner	1	0	0	0	0	0
Earley	1	1	1	1	0	0

U — Gormely, Valentine, McKinley. T—2:30. A—5,780 (paid).

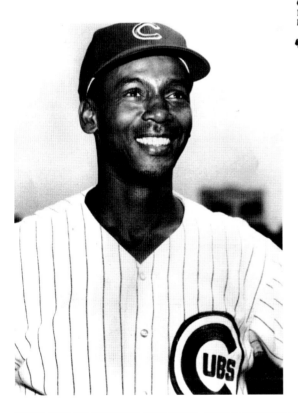

MR. CUB. Homering for the Cubs was Ernie Banks (HOF, pictured at left), with a 450-foot shot to left center. In 19 years with the Cubs, the two-time NL Most Valuable Player hit 512 home runs, leading the league twice in home runs and twice in RBI. Banks hit more than 20 home runs in a season 12 times. (NBHOF.)

MR. CONSISTENCY. Billy Williams (HOF, pictured at left), who would go 0-3 that day, spent all but 2 of his 18 big-league seasons with the Cubs. He compiled a .290 lifetime average and hit 426 home runs, slugging 20 or more home runs 13 straight seasons. His only postseason play was with Oakland in 1975. (NBHOF.)

ERNIE BROGLIO? Soon to be traded to the Cardinals for Ernie Broglio, Lou Brock (HOF, pictured at right) went 0-4. He would compile 3,023 hits over his 19-year career, lead the league in stolen bases seven times, and set the career stolen-base record (938). The mark stood until it was broken by Ricky Henderson. (NBHOF.)

PRIDE OF THE BLEACHER BUMS.
Ron Santo (HOF, pictured at right)
singled and scored a run. He would
play 14 of his 15 big-league seasons
with the Cubs, hitting over 30 home
runs four times and driving in over
100 runs four times. A fan favorite
with the Cubs, he finished his career
with the White Sox. (NBHOF.)

YAZ. Carl Yastrezemski (HOF,
pictured at left) was on his way to
becoming the heart of two pennant-
winning Red Sox teams, compiling
3,419 hits and 452 home runs over
a 23-year career. All that being said,
that day he went 0-3 against the
Cubs. (NBHOF.)

JUST AROUND THE CORNER. Dick Williams (HOF, pictured at left) played in a utility role for 13 years with five teams. His entry into Cooperstown was based upon the two world championships and four pennants he earned in 22 years of managing six different teams. Williams's first pennant came as manager of the 1967 "Impossible Dream" Red Sox team. (NBHOF.)

THE REVENGE OF DR. STRANGEGLOVE. At first base for the Red Sox was slugger Dick Stuart (pictured at right), who led the AL with 118 RBI the year before, when he also had a career high 42 home runs. Stuarts's nickname, "Dr. Strangeglove," was based on the title of a popular film and was earned by his terrible fielding. Some fans behind the Red Sox dugout gave Stuart a rough time all day, calling him "Iron Mitt" and "Cement Hands." Stuart hit a towering home run off the top of the scoreboard, and, as he rounded third base, he looked at the group and thumbed his nose. (NBHOF.)

ALL PHILLIES,
ALL THE TIME

FULL CROWD. With the departure of the Reading Indians after the 1965 season, for the second time in four years Reading fans did not have a baseball team in town. Then the Phillies decided to move its AA franchise from Macon, Georgia, to Reading, with the team to play in the Eastern League. A sign of the enthusiasm that greeted the RPhils when they arrived was a capacity crowd on opening night (pictured), a rare occurrence at the stadium over the years. As part of their arrangement with the RPhils' owners, the Phillies agreed to come to Reading to play the RPhils in an annual exhibition game, the first of which occurred before yet another packed house on June 8. RPhils ownership relied heavily on the team's share of the large gate that the annual game would draw, as crowds at the stadium were not like the current day; the total annual attendance at RPhils games exceeded 100,000 only twice in the first 20 years of the franchise. The series would continue annually (except for occasional rainouts) until the Phillies announced in 1989 that the games would alternate between the AA and the AAA teams. The games continued in this format (except for 1994, when a mutually acceptable date was not available) until the 2000 game, the last of the series. (Reading Fightins' files.)

Time to Switch?

Philadelphia	ab	r	h	bi		READING	ab	r	h	bi
Clem'ns lf	4	1	2	1		Perkins lf	4	0	0	0
Taylor 1b	2	0	1	0		Bedell lf	1	0	0	0
Franc'a 1b	1	0	0	0		Shoe'er 2b	4	2	1	0
Allen 3b	2	1	1	1		Kol'sky cf	5	1	1	0
Groat 3b	2	0	0	0		Toms'll 3b	4	2	2	1
Callis'n rf	2	0	0	0		Camp'll 1b	1	2	1	1
Brant rf	2	0	0	0		Watkins rf	3	1	1	3
Lock cf	2	0	0	0		Halv'en ss	4	0	2	3
Briggs cf	1	0	0	0		Cherry c	4	0	0	0
Rojas 2b	2	0	0	0		Chan'is c	0	0	0	0
Linz 2b	2	0	1	0		Pollard p	2	0	0	0
Suth'd ss	1	1	0	0		Reams ph	1	0	1	0
Wine ss	2	0	0	0		Wilson p	1	0	0	0
Oliver c	2	0	1	0		Brown p	0	0	0	0
Dalry'le c	2	0	2	0						
Lough'n p	1	0	0	0		Totals	34	8	9	8
White ph	1	0	0	0						
Jack'on pr	0	1	0	0						
Vattimo p	0	0	0	0						
Hoak ph	2	0	0	0						
Haag p	0	0	0	0						

Totals 33 4 8 2

Philadelphia 200 020 000—4
READING 000 251 00x—8

E—Linz 3, Halversen, Kolinsky. DP—READING 1. LOB—Philadelphia 1, READING 7. 2B—Halversen, Kolinsky, Dalrymple. 3B—Watkins. HR—Clemens, Allen. SF—Campbell.

	IP	H	R	ER	BB	SO
Loughlin	4	3	2	2	3	2
Vattimo (L)	2	6	6	4	1	3
Haag	2	0	0	0	0	3
Pollard (W)	5	5	4	3	1	4
Wilson	3	1	0	0	1	1
Brown	1	2	0	0	1	1

WP—Laughlin. T—2:25. A—8,201.

JUNE 8, 1967: RPHILS 8, PHILLIES 4. In front of a packed house of 8,269, the largest paying crowd in the stadium's history, the RPhils took advantage of the pitchers the Phillies had brought up from Class A ball for the game. Gene Mauch (pictured below) managed the Phillies from the bench in street clothes. The RPhils rallied from a two-run deficit with eight runs. As a gesture of goodwill, the parent club, on orders from owner Bob Carpenter, allowed the RPhils to keep the entire gate. (Left, *Reading Eagle* files; below, Phillies.)

ALL PHILLIES, ALL THE TIME

HOMEBOY HOMER. Leesport native Doug Clemens (RHOF, pictured at right) supplied instant drama, leading off the game with a home run. One batter later, Dick Allen homers to put the visitors up 2-0, a lead that would not last. Gene Mauch was managing the Phillies in street clothes. (Private collection of Charles J. Adams III.)

TRIO OF HISTORY. In an attempt to get back to the major leagues, former Phillies great Robin Roberts (HOF, RHOF) pitched for the RPhils during part of the 1967 season. Here, Roberts (right) talks with RPhils player-coach, former Phillie Dallas Green (RHOF, left), and RPhils manager Frank Lucchesi (RHOF, center). The latter two would each go on to manage Philadelphia. (Reading Fightins' files.)

Philadelphia	ab	r	h	bi	READING	ab	r	h	bi
Rojas 2b	1	1	0	0	Doyal 2b	4	1	0	0
Pena ss	5	1	3	1	Skrable cf	4	0	2	0
Gon'lez cf	2	0	0	0	Bedell lf	3	0	0	0
Lock cf	3	0	0	0	G.Torres lf	1	0	1	1
Allen lf	2	0	1	1	Reams rf	3	0	0	0
White lf	3	2	2	2	Watkins c	1	0	0	0
Callison rf	3	1	2	0	McGraw c	2	0	1	0
Ryan rf	1	0	0	0	Allen 1b	2	1	1	0
Briggs 1b	3	1	1	1	Kol'sky rf	2	0	1	0
Joseph 3b	3	0	0	0	Bowa ss	4	0	0	0
Dalry'ple c	1	0	0	0	V.Tor's 3b	2	0	1	1
Sullivan c	2	0	0	0	Leek 3b	2	1	1	0
Johnson p	2	0	0	0	Hammitt p	2	0	0	0
G.Ja'on ph	1	1	1	0	Chr'her ph	1	0	1	0
Wagner p	1	0	1	1	Rou'ville p	0	0	0	0
Total	36	7	12	6	Total	33	3	9	2

Philadelphia 100 001 131—7
READING 010 000 020—3

E — R. Allen. DP — Philadelphia 3,
READING 3. LOB — Philadelphia 6,
READING 5. 2B — Skrable, White,
Briggs.

	IP	H	R	ER	BB	SO
Johnson (W)	6	4	1	1	0	5
Wagner	3	5	2	2	2	3
Hammitt (L)	8	11	6	6	2	2
Rounsaville	1	1	1	1	0	0

HBP—By Hammitt (Dalrymple, Jo-
seph). WP—Wagner. PB—McGraw. T—
2:05. A—7,339.

JULY 18, 1968: PHILLIES 7, RPHILS 3. Bill White hit a home run and a double to lead the Phillies offense. In left field for the visitors was Dick Allen, and his brother Ron (RHOF) played first base for Reading. (Ron's nine home runs would lead the RPhils that season, the "Year of the Pitcher.") In the lineup for Reading were future Phillies Larry Bowa (RHOF) and Denny Doyle (RHOF). Veteran major-leaguer Joe Christopher, playing for the RPhils that season in an attempt to get back to the big leagues, had a pinch single. The game was played as the first of a doubleheader, with the RPhils playing a regulation game against Waterbury in the nightcap. (The RPhils won the nightcap, and the gate was 7,339.) (*Reading Eagle* files.)

STREAK BREAKER. In left field and going 0-3 for the RPhils was player-coach Howie Bedell (RHOF, pictured above), one of three seasons the Pottstown native would play in Reading. Up with the Phillies earlier that year, in one of his two career stints in the major leagues, Bedell hit a sacrifice fly that ended Don Drysdale's record string of 58 scoreless innings. (Reading Fightins' files.)

ALL PHILLIES, ALL THE TIME

Big League?

Philadelphia	ab	r	h	bi		READING	ab	r	h	bi
Taylor 3b	1	0	0	0		Kelly lf	4	0	0	0
Barry lf	1	0	0	0		Jagutis ss	2	1	2	3
Rojas 2b	2	0	0	0		Cox 3b	4	2	2	1
Palmer p	0	0	0	0		Allen 1b	1	0	1	1
Seminick c	1	0	0	0		Leek 3b	1	2	1	0
Callison rf	1	0	1	0		Wellmn ph	1	0	1	0
Watkins rf	1	0	0	0		Stone rf	3	1	1	1
Johnson 1b	2	0	0	0		Kolinsky cf	4	1	1	1
Widmar p	0	0	0	0		Merrill c	3	1	2	0
Stone lf	3	0	0	0		Francis c	1	0	0	0
Money ss	3	0	1	0		Locanto 2b	3	0	1	1
Ryan c	1	0	0	0		Terlecki p	0	0	0	0
Roznovsky c	2	0	0	0						
Hisle cf	2	0	0	0		Totals	29	8	12	8
Farrell p	0	0	0	0						
Harmon 2b	2	0	0	0						
Totals	23	0	2	0						

Philadelphia 000 000 0—0
READING 204 002 x—8

E—Seminick. LOB — Philadelphia 4, Reading 8. 2B—Allen, Stone. HR—Jagutis, Cox. SB—Johnson.

	IP	H	R	ER	BB	SO
Farrell (L)	2	4	2	2	2	0
Rojas	⅔	4	4	4	2	0
Palmer	2⅓	1	0	0	0	03
Widmar	1	3	2	2	0	0
Laxton (W)	5	2	0	0	0	0
Terlecki	2	0	0	0	0	0

T—1:35. A—5,005.

AUGUST 7, 1969: RPHILS 8, PHILLIES 0. The Phillies mustered all of two hits in a game played at the end of a tumultuous day for the team. Manager Bob Skinner quit over issues with Dick Allen, citing lack of support from the front office. He was replaced by third-base coach George Myatt. The fans see Phillies infielder Cookie Rojas pitch two-thirds of an inning and Phillies pitching coach Al Widmar throw the final inning of the game, with coach Andy Seminick (RHOF), a former Whiz Kid and future RPhils manager, behind the plate. Reading manager Bob Wellman (RHOF), a former member of the Philadelphia A's, hit a pinch single. Of the substitutions, Duke DeLuca wrote in the *Reading Eagle*, "It was an exhibition, nothing more, nothing less, for Myatt and the big leaguers." Staged as the first game of a doubleheader (the RPhils lost to Waterbury in the nightcap), the game drew a crowd of 5,005, part of a markedly downward trend. (*Reading Eagle* files.)

TMI. With the game heavily covered by the Philadelphia media because of Skinner's resignation, John Smith wrote in the *Reading Eagle* that newly appointed Phillies manager George Myatt (pictured at left) held an impromptu postgame press conference in the office of Reading manager Bob Wellman "wearing nothing but a can of Budweiser." Myatt, who managed the team for the balance of the season, said of Allen, "I know he's very unhappy. Maybe I can make him happy." (NBHOF.)

TROUBLED STAR. The center of controversy on several occasions that season involving late arrivals or missed travel arrangements, Dick (then referred to as Richie) Allen (pictured at right) would nevertheless lead the Phillies with 32 home runs. Skinner cited lack of support from the front office as the basis for his resignation. Ironically, because of confusion on travel arrangements that day, Allen was not present at the game. (NBHOF.)

ALL PHILLIES, ALL THE TIME

PHILADELPHIA	ab	r	h	bi	READING	ab	r	h	bi
Taylor 2b	2	0	0	0	Kelly lf	3	0	0	0
Doyle 2b	2	0	0	0	Roberts lf	1	0	0	0
Harmon ss	4	0	0	0	Starnes cf	4	0	0	0
Money 3b	3	1	1	1	Rogodz'ski rf	4	0	2	0
Hutto 3b	1	0	1	0	Luzinski 1b	3	0	0	0
Johnson 1b	2	0	0	0	Cox 3b	1	1	0	0
Joseph 1b	2	0	0	0	Rojas 3b	2	0	0	0
Stone lf	3	2	1	0	Silicato 2b	4	1	1	1
Hisle cf	2	0	0	0	Francis c	3	0	0	0
Browne cf	2	0	0	0	Robinson ss	2	0	1	1
Gamble rf	2	1	2	2	Urrieta ss	1	0	0	0
Ryan c	2	0	0	1	Clem p	2	0	1	0
Edwards c	1	0	0	0	Rodriguez ph	1	0	1	0
Herron p	2	0	0	0	Horne p	0	0	0	0
Wallace p	0	0	0	0					
Briggs ph	1	0	0	0	Totals	31	2	6	2
King p	0	0	0	0					
Totals	31	4	5	4					

```
Philadelphia .............. 120 100 000 — 4
READING    ............. 020 000 000 — 2
```

E — Cox. DP — Philadelphia 2. LOB — Philadelphia 2; READING 4. 2B — Clem, Philadelphia 2; READING 4. 2B—Clem, Money. SF—Gamble.

	IP	H	R	ER	BB	SO
Herron (W)	5	5	2	2	2	2
Wallace	3	1	0	0	1	1
King	1	0	0	0	0	2
Clem (L)	7	4	4	3	1	1
Horne	2	1	0	0	0	1

WP—Herron. T—1:40. A—4,239.

JULY 30, 1970: PHILLIES 4, RPHILS 2. Describing what would be a future trend, the *Reading Times* headline on the day of the annual exhibition read, "Yesteryear Phillies to Play Future Phils." Frank Lucchesi became the first of three former Reading managers to appear later at the annual exhibition game as manager of the Phillies. Experiencing similar homecomings would be John Felske in 1985 and Lee Elia (RHOF) in 1988. Other returning Reading alumni that night included Phillies shortstop Larry Bowa and second baseman Denny Doyle, plus former Reading Red Sox players, catcher Mike Ryan and pitcher Fred Wenz. With the game scheduled as the first of a doubleheader (the nightcap against Elmira was rained out), the crowd was only 4,239. (*Reading Eagle* files.)

GNAT. Popular with Reading fans after spending two seasons with the RPhils, Larry Bowa (pictured at left) would spend 12 of his 16 major-league years with the Phillies. A superb fielder who made himself a respectable hitter (with a .260 lifetime average), Bowa would be named an all-star five times and was part of the nucleus of a Phillies team that played in the postseason six times. The Phillies were led on offense by a homer by Don Money (pictured below) and Oscar Gamble's two RBI. Money spent five seasons with the Phillies, failing to achieve the star status that the club thought he would achieve when he was acquired as the key player in the 1967 trade that sent Jim Bunning to the Pirates. Money fared better after being traded to the Brewers, playing 11 more seasons and being named to four all-star teams. (Left, Reading Fightins' files; below, Phillies.)

ALL PHILLIES, ALL THE TIME

JUNE 17, 1971: PHILS 4, RPHILS 3. Heralding (in a somewhat understated manner) the beginning of an era of Phillies history that would end 18 years later, the headline in the *Reading Times* proclaimed, "Phillies Victors, 4-3 on Draftee's Homer." Newly signed Mike Schmidt (HOF, RHOF), in his professional debut playing shortstop in place of Larry Bowa (out with a cold that night), homered off Mike Fremuth, which turned out to be the winning hit. Winning pitcher Lowell Palmer is seen below in a rare photograph without the sunglasses he wore when he pitched (as well as on all of his baseball cards) during his five-year big-league career, three of which were with the Phillies. The game was staged as the first of a doubleheader, with the crowd of 3,377 for the fourth time being smaller than that of the preceding year. (The RPhils lose to Elmira in the nightcap.) (Right, *Reading Eagle* files; below, Phillies.)

Philadelphia	ab	r	h	bi	Reading	ab	r	h	bi
Harm'n 2b	2	0	0	0	Kurtz 3b	4	0	0	0
Pfeil 2b	3	0	0	0	Rodr'z lf	2	1	0	0
McC'er c	3	1	1	0	Rog'ski rf	3	1	2	2
Ryan c	1	0	0	0	Wissel 1b	4	0	0	0
Doyle 2b	0	0	0	0	Boone c	4	0	0	0
Stone rf	2	1	0	0	Starnes cf	4	0	0	0
John'n 1b	3	1	1	1	Coluc'o 2b	4	1	1	1
Mont'ez 1b	1	0	0	0	Russo ss	2	0	0	0
Lis lf	3	0	0	0	Wallace p	1	0	0	0
Gamble cf	4	0	0	0	Frem'h p	1	0	0	0
Vulco'h 3b	4	0	1	1	Cox ph	1	0	0	0
Schm't ss	3	1	1	1	Clem p	0	0	0	0
Cham'n p	1	0	0	0					
Palmer p	2	0	0	0					
Totals	32	4	4	3	Totals	30	3	3	3

```
Philadelphia        300 000 100—4
Reading             000 012 000—3
```

E—Russo, Vukovich. DP — Reading 1. LOB—Philadelphia 5, Reading 4. 2B—McCarver, Vukovich. HR — Colucio, Rogodzinski, Schmidt. SB — Rogodzinski.

	IP	H	R	ER	BB	SO
Champion	5	2	1	1	1	5
Palmer (W)	1	1	2	2	3	3
Wallace	4	3	3	3	1	2
Fremuth (L)	3	1	1	1	2	2
Clem	2	0	0	0	2	2

PB—Boone. T—2:03.

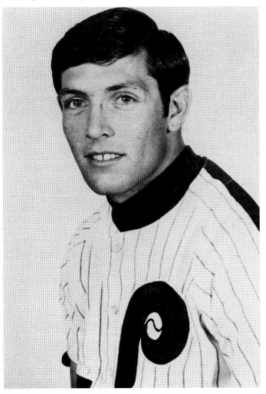

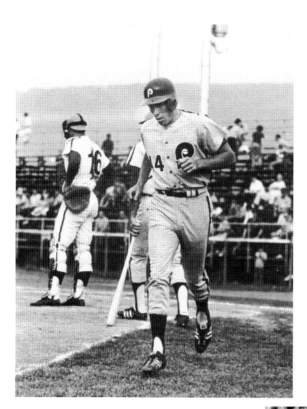

FIRST OF MANY. Mike Schmidt made his way back to the dugout after hitting what would be the deciding blow of the game. Reading catcher Bob Boone (RHOF) is in the background. Schmidt spent the rest of the season at Reading. He hit 548 home runs in his 18-year career with the Phillies. (*Reading Eagle* files.)

ROGO ROOTER. Homering for the RPhils and driving in two runs was right fielder Mike Rogodzinski (pictured at right), who would spend three seasons in Reading and parts of three seasons in Philadelphia. Used by the Phillies primarily as a reserve and a pinch-hitter, Rogodzinski's plate appearances were greeted by the scoreboard at Veterans Stadium with the message, "I'm a Rogo Rooter." (Phillies.)

ALL PHILLIES, ALL THE TIME

JUNE 5, 1972: PHILS 10, RPHILS 2. There were 3,432 fans on hand for the 5:30 p.m. game in which the Phillies beat Reading. The RPhils were managed by Jim Bunning (HOF, RHOF). Only a few are on hand to see the conclusion of the 13-inning nightcap, a loss to Trois Rivieres that ended at 12:15 a.m. "Was This Necessary?" was the headline on Duke DeLuca's game account in the *Reading Eagle*. (Showing the power of the press, this would be the last of the exhibition game doubleheaders.) After a 17-season big-league career in which he would post 224 victories, winning more than 100 games in each league, Bunning (pictured below) managed five years in the Phillies farm system, with the RPhils being his first stop. Frustrated with his failure to be named a big-league manager, Bunning turned to a career in politics, serving in the House of Representatives and then the Senate. (Right, *Reading Eagle* files; below, Phillies.)

EXHIBITION

Philadelphia	ab	r	h	rbi		Reading	ab	r	h	rbi
Bowa ss	5	0	1	1		Garcia cf	5	0	1	0
Doyle 2b	4	1	1	0		Starnes lf	2	1	1	0
Money 3b	5	1	1	0		Sanchez p	0	0	0	0
Luzinski lf	2	1	0	0		Saferight c	3	0	0	0
Browne lf	1	2	1	0		Grallella rf	4	0	0	0
Freed rf	2	3	1	0		Hedge 3b	4	0	2	1
Johnson 1b	2	0	1	1		Beall 1b	2	1	0	0
Koegel 1b	2	1	2	4		Diorio p	0	0	0	0
Montanez cf	4	0	1	1		Silicat o2b	2	0	0	0
McCarver c	0	1	0	0		Kinzel 2b	2	0	1	0
Ryan c	2	0	1	1		Santana ss	3	0	1	0
Selma p	2	0	0	0		Bozich ss	1	0	0	0
Short p	0	0	0	0		Easlan c	2	0	1	0
Gamble ph	1	0	0	0		Meyer p	0	0	0	0
Reynolds p	0	0	0	0		Ziegler 1b	1	0	0	0
Hatton ph	1	0	0	0		Horne p	0	0	0	0
Twitchell p	0	0	0	0		Hutchinson lf	4	0	0	0
Totals	33	10	10	8		Totals	35	2	7	1

Philadelphia 010 012 033—10
Reading 100 100 000— 2

E—Doyle. McaCrver. Saferight. Bozich. DP—Reading 1. LOB—Philadelphia 8, Reading 10. 2B—Johnson. Doyle. Money. Kinzel. HR—Koegel. SB—Starnes. S—Selma. SF—Ryan.

	IP	H	R	ER	BB	SO
Selma (W	6	5	2	1	3	6
Short	1	1	0	0	1	2
Reynolds	1	1	0	0	0	2
Twitchell	1	0	0	0	0	0
Horne ············	3	1	1	1	3	2
Sanchez	2	2	1	1	1	0
Meyer (L	3	6	5	5	2	1
Diorio	1	1	2	1	4	0

PB—McCarver. T—2:25.

KOEGEL BLITZ. Leading the Phillies attack that night, going 2-2 with a home run and four RBI, was utility man Pete Koegel (pictured at left), who otherwise batted .141 that season. He appear in 41 games that year, the most in any of his four seasons in the big leagues with the Brewers and the Phillies. (TSB.)

NO BULL BLAST TONIGHT. Greg "Bull" Luzinski (RHOF, pictured at right) was greeted with the loudest applause of the night when he first came to bat in his return to the stadium where he had clubbed 33 home runs and drove in 120 runs in 1970 for the RPhils. He would go 0-2 with a walk (he treated Reading fans with homers in two future exhibitions, however). Luzinski hit 307 home runs over a 15-year big-league career, 11 of which were spent with the Phillies, where he was selected to four all-star teams. (Phillies.)

ALL PHILLIES, ALL THE TIME

AUGUST 15, 1974: RPHILS 6, PHILS 3.

With no doubleheader scheduled, a crowd of 6,287 saw the RPhils get four runs off former RPhil Mac Scarce (pictured below) on the way to beating the "Yes We Can" Phillies. Future Phillies Rick Bosetti and Fred Andrews each got two hits for the home team. In the starting lineup for the Phillies that night were future RPhils managers Tony Taylor (managing in 1985) at third base and Bill Robinson (managing in 1996) in center field. In 23 relief appearances with the 1972 RPhils, Scarce posted a miniscule 0.46 ERA with 54 strikeouts in 39 innings. He was promoted to the majors over the objection of RPhils manager Jim Bunning, who contended that Scarce did not yet have sufficient control of his best pitch, a slider. After three seasons with the Phillies, Scarce was sent to the Mets in a trade for Tug McGraw. (Right, *Reading Eagle* files; below, Phillies.)

Philadelphia					Reading				
Cash 2b	2	0	0	0		ab	r	h	bi
Taylor 2b, 3b	3	1	2	2	Bosetti cf	5	1	1	0
Boone c	2	0	0	0	M'L'ghlin 2b	5	0	1	2
Oates c	3	1	0	0	Jones lf	5	0	2	0
Martin cf	5	0	1	1	Stitzel dh	5	0	3	0
McGraw cf	0	0	0	0	Iorg 1b	4	0	1	0
Luzinski lf	2	0	1	0	Bastable c	3	1	0	0
Fritz 1b	2	0	0	0	Rogozinski c	1	1	1	1
Johnstone rf	3	0	0	0	Klobas 3b	4	1	2	2
And'n ph, rf	1	0	0	0	Fitzgerald rf	2	0	0	0
Hutton 1b, lf	3	1	2	0	Quintana rf	2	0	1	0
Schm't 3b, ss	3	0	1	0	Dancy ss	4	1	1	0
H'mon ss, 2b	2	1	1	0	Seoane p	0	0	0	0
Hilgendorf p	0	0	0	0	Kniffin p	0	0	0	0
Schueler p	0	0	0	0	Boitano p	0	0	0	0
Horner p	0	0	0	0					
Christ'nson p	0	0	0	0					
Allen dh	2	0	0	0					
Brown dh	2	1	0	1					
Totals	35	5	8	4	**Totals**	40	5	13	5

Philadelphia 000 000 104 — 5
Reading 020 000 003 — 5

E — Dancy, Harmon, Quintana, DP — Reading 1. LOB—Philadelphia 8, Reading 8. 2B—Stitzel 2, Martin, McLaughlin. 3B—Taylor. HR — Klobas, Rogadzinski. SB — Quintana, Brown. S—Harmon.

	IP	H	R	ER	BB	SO
Hilgendorf	3	2	2	2	0	1
Scheuler	2	1	0	0	0	1
Hoerner	1	3	0	0	0	1
Christenson	2	2	0	0	0	2
Ribblemeyer	1	5	3	3	0	0
Seoane	7	5	1	1	3	6
Kniffin	1⅓	1	1	1	1	2
Boitano	⅔	2	3	2	0	0

WP—Christenson, Kniffin, Boitano. T—2:31. A—4,507.

Philadelphia					Reading				
						ab	r	h	bi
Cash 2b	2	0	0	0					
Taylor 2b, 3b	3	1	2	2	Boselli cf	5	1	1	0
Boone c	2	0	0	0	M'L'ghlin 2b	5	0	1	2
Oates c	3	1	0	0	Jones lf	5	0	2	0
Martin cf	5	0	1	1	Slitzel dh	5	0	3	0
McGraw cf	0	0	0	0	Iorg 1b	4	0	1	0
Luzinski lf	2	0	1	0	Bastable c	3	1	0	0
Fritz 1b	2	0	0	0	Rogozinski c	1	1	1	1
Johnstone rf	3	0	0	0	Klobas 3b	4	1	2	2
And'n ph, rf	1	0	0	0	Fitzgerald rf	3	0	0	0
Hutton 1b, lf	3	1	2	0	Quintana rf	2	0	1	0
Schm't 3b, ss	3	0	1	0	Dancy ss	4	1	1	0
H'mon ss, 2b	2	1	1	0	Seoane p	0	0	0	0
Hilgendorf p	0	0	0	0	Kniffin p	0	0	0	0
Schueler p	0	0	0	0	Baitano p	0	0	0	0
Horner p	0	0	0	0					
Christ'nson p	0	0	0	0					
Allen dh	2	0	0	0					
Brown dh	2	1	0	1					
Totals	35	5	8	4	Totals	40	5	13	5

Philadelphia 000 000 104 — 5
Reading 020 000 003 — 5

E — Dancy, Harmon, Quintana. DP — Reading 1. LOB—Philadelphia 8, Reading 8. 2B—Slitzel 2, Martin, McLaughlin. 3B—Taylor. HR — Klobas, Rogadzinski. SB — Quintana, Brown. S—Harmon.

	IP	H	R	ER	BB	SO
Hilgendorf	3	2	2	2	0	1
Schueler	2	1	0	0	0	1
Hoerner	1	3	0	0	0	1
Christenson	2	2	0	0	0	2
Ribblemeyer	1	5	3	3	0	0
Seoane	7	5	1	1	3	6
Kniffin	1⅓	1	1	1	1	2
Boitano	⅔	2	3	2	0	0

WP—Christenson, Kniffin, Boitano. T—2:31. A—4,507.

MAY 29, 1975: 5-5 TIE. In a drama that could be titled "Rogo's Revenge," former Phillie Mike Rogodzinski (now back with the RPhils and disappointed with his demotion) homered as part of a three-run rally that ties the game in the bottom of the ninth inning. Playing first base for the Phillies was former RPhil Larry Fritz, on eve of making his major-league debut, his only appearance in a major-league game. (*Reading Eagle* files.)

DO WHAT I SAY. Phillies pitching coach Ray Rippelmeyer (pictured at right) gives up five hits and three runs in the bottom of the ninth inning, blowing a save for somebody on the Phillies staff who the official scorer would have had to figure out since no pitcher threw more than two innings. It would be one of several mound appearances in these exhibition games he would make during his nine-year tenure as Phillies pitching coach. Rippelmeyer had an 11-year minor-league career, pitching briefly with the 1962 Washington Senators (NBHOF.)

ALL PHILLIES, ALL THE TIME

PRODIGAL SON RETURNS.
Reacquired by the Phillies, Dick
Allen (pictured at right) signed
autographs and was a big hit
with the Reading fans. All was
forgiven. That evening, RPhils
pitcher Manny Seone (a future
Phillie in 1977, albeit only for two
games) struck him out twice. For
the season, Allen hit .233 with 12
home runs. (NBOHF.)

CENTER FIELD. Phillies reliever
and fan favorite Tug McGraw
(pictured at left) played center
field in the ninth inning, inserted
by manger Danny Ozark for the
express purpose of allowing him
to show his talent of catching a
ball behind his back. McGraw
demonstrated this skill during
warm-up tosses. Though the
entire team stood on the front
step of the dugout hoping a fly
ball would come their way, no
fly balls were hit in McGraw's
direction. (NBOHF.)

READING	ab	r	h	rbi	Philadelphia	ab	r	h	rbi
Gonzalez dh	5	0	0	0	Martin cf	4	2	1	1
Dancy 2b	4	1	2	0	Bowa ss	1	2	1	0
Poff lf	3	0	1	0	Cash 2b	1	0	0	0
Begnaud 1b	3	0	1	0	Taylor 3b	2	0	1	2
Fitzgerald rf	4	0	1	0	Schmidt 3b	2	0	1	0
Oliveras 3b	4	1	1	0	Blackwell c	2	0	1	0
Gardner cf	3	1	0	1	Luzinski lf	2	1	1	2
Cruz ss	4	0	2	1	Johnstone rf	3	0	0	0
Baker c	4	0	0	0	Brown rf	1	0	0	0
Gibson p	0	0	0	0	McCarver lf	3	1	1	0
Klein p	0	0	0	0	Hutton 1b	3	0	2	1
White p	0	0	0	0	Ozark 1b	1	0	0	0
Gregson p	0	0	0	0	Boone c-3b	3	0	0	0
Brenizer p	0	0	0	0	Harmon 2b	2	0	1	1
					Vukov. 2b-ss	4	0	1	0
					Underwood p	1	0	0	0
					Twitchell p	1	0	0	0
					Tolan ph	1	1	1	0
					Schueler p	1	0	0	0
					Ripplem. p	0	0	0	0
Totals	34	3	8	2	Totals	38	7	12	7

```
Philadelphia    202 002 100— 7
READING         010 001 001— 3
```

E—Johnstone, Gardner, Cruz. DP—Philadelphia, READING 1. LOB—Philadelphia 9, READING 7. 2B—Hutton, Tolan, Cruz, Fitgerald. 3B—Taylor, Oliveras. HR—Martin, Luzinski. SF—Hutton.

	IP	H	R	ER	BB	SO
Underwood (W)	2	1	1	1	2	1
Twitchell	3	1	0	0	0	6
Schueler	2	2	1	0	1	2
Ripplemyer	2	4	1	1	0	0
Gibson (L)	4	6	4	4	2	4
Klein	2	3	2	2	2	0
White	1	2	1	1	0	1
Gregson	1	1	0	0	0	1
Brenizer	1	0	0	0	0	1

WP—Underwood, White. T—2:11. A—6,146.

MAY 10, 1976: PHILLIES 7, RPHILS 3. It was a big day for former RPhils as Greg Luzinski and Jerry Martin each homered to lead the Phillies attack. (Is it not tough to read a sentence containing the words "Luzinski" and "Martin" without thinking of . . . ? Oh, never mind.) Making another mound appearance was Ray Rippelmeyer. (*Reading Eagle* files.)

ALL PHILLIES, ALL THE TIME

DANNY TAKES SOME CUTS. Manager Danny Ozark (pictured, right) appeared as a pinch-hitter in the sixth inning and flew out to right. A former first baseman, Ozark hit .282 in 18 minor-league seasons in the Dodgers system. More dramatic was Phillies outfielder Jay Johnstone calling a shot like Babe Ruth, then hitting into a double play. (NBHOF.)

WINNING BOTH WAYS. The winning pitcher was former RPhil Tom Underwood (RHOF, pictured at left). With the RPhils in 1974, Underwood was the winning pitcher in the game against Philadelphia, while posting a stellar record of 14-5 that season. He would spend three full seasons and part of another in Philadelphia and would spend a total of 11 seasons in the major leagues. (NBHOF.)

Philadelphia	ab	r	h	bi	READING	ab	r	h	bi
Martin cf	4	0	0	0	Moreno 2b	4	0	0	0
Bowa ss	2	0	0	0	Brown cf	3	2	1	0
Sizem ss	1	0	0	0	Morel dh-c	4	0	1	0
Schmidt 3b	2	0	0	0	Poff 1b	3	0	2	0
Johnson 3b	1	0	0	0	Vukovich 3b	2	0	0	1
Luzinski lf	2	1	1	1	Oliveros 3b	2	0	1	0
McCarver c	2	0	0	0	Guarn rf	2	0	0	0
Johnstone rf	4	0	2	0	Skavsky rf	1	0	0	0
Boone c	2	0	1	0	Blackw c	2	0	0	0
Brusstar p	0	0	0	0	DeMeo c	0	0	0	0
Brown ph	1	0	0	0	Convert lf	2	0	0	0
King p	0	0	0	0	R Contr lf	1	0	0	0
Hutton 1b	0	0	0	0	Cruz ss	3	0	0	0
Iorg 1b-lf	2	0	0	0	Hernaiz p	0	0	0	0
Andrews 2b	3	0	0	0	Kienp	0	0	0	0
Underw p	0	0	0	0	N Contr p	0	0	0	0
Kaat p	1	0	0	0	Manos p	0	0	0	0
Toan 1b	2	0	0	0					
Rppelm p	0	0	0	0	Totals	29	2	5	1
Totals	30	1	4	1					

```
Philadelphia        010 000 000—1.
READING             100 000 01x—2
  E—Johnson, Sizemore  LOB—Phila  4,
READING 7  2B—Poff  HR—Luzinski
```

	IP	H	R	ER	BB	SO
Underwood	2	1	1	1	2	2
Kaat	2	0	0	0	0	1
Brusstar	2	0	0	0	0	1
King	1	2	0	0	2	0
Rippelmeyer (L)	1	2	1	0	0	0
Hernaiz	4	4	1	1	0	4
Kien	2	0	0	0	0	2
N Contreras (W)	2	0	0	0	1	2
Manos	1	0	0	0	1	0

```
  Save—Manos
  T—1 42  A—4,789.
```

APRIL 25, 1977: RPHILS 2 PHILS 1. The Phils started eight former RPhils: Jerry Martin, Larry Bowa, Mike Schmidt, Greg Luzinski, Bob Boone (RHOF), Dane Iorg, Fred Andrews, and Tom Underwood. RPhil John Poff drove in the go ahead run for the RPhils in the eighth inning and avoided, in the words of the *Reading Eagle*'s John Smith, the potential "horror of horrors" of the game going into extra innings. Getting hung with the loss was Phillies pitching coach Ray Rippelmeyer. The Phillies lone run came with Greg Luzinski's homer in the second inning, the second year in a row the Reading fans witnessed a "Bull Blast." (*Reading Eagle* files.)

HE GOT AROUND. Scoring both runs for the RPhils was future Yankee/Padre/Blue Jay/Mariner Bobby Brown (HOF, pictured at right). Brown would hit .290 for the RPhils that season, and in 1978, he would be traded to the Yankees (along with Jay Johnstone for Rawley Eastwick), where he would spend three of his seven big-league seasons. He would appear in postseason play with the 1980 and 1981 Yankees as well as the 1984 Padres. Brown would play in seven different organizations over the course of his career. (NBHOF.)

ALL PHILLIES, ALL THE TIME

Tainted I. Playing third base for the Phillies was Davey Johnson (pictured at right), who failed to catch John Poff's blooper to left field, then fails to chase the ball down while Reading's Bobby Brown evoked memories of Enos Slaughter's "Mad Dash," scoring from first base. That season, sharing a platoon of first base with Richie Hebner, Johnson batted .321. Following a 13-year big-league career, Johnson managed five different major-league teams over 17 seasons. His teams played in the postseason six times. (Phillies.)

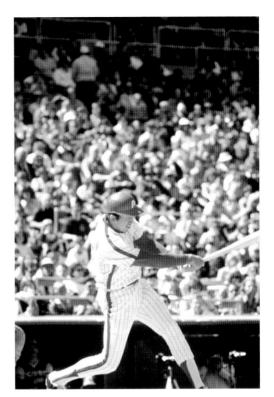

Tainted II. RPhils outfielder/first baseman John Poff (pictured at left) played briefly with Philadelphia in 1979. Of Johnson's efforts in going after the pop-up that fell in as a double and turned out to be the winning blow, Poff said afterward, "I don't think he tried too hard on that." (NBHOF.)

Philadelphia	ab	r	h	bi	READING	ab	r	h	bi
McBride rf	2	1	2	0	Berger cf	4	0	1	1
Johnstone rf	3	0	1	0	Aguayo ss	4	0	2	0
Bowa ss	2	0	0	0	Conv'no lf	4	1	1	0
McCarver lf	2	0	1	0	Hughes dh	4	0	1	1
Schmidt 3b	2	0	2	1	Matuszek 1b	4	0	0	0
Foote c	2	0	0	0	Oliveros 3b	4	1	2	1
Luzinski lf	2	0	0	0	Guarnia rf	3	0	0	0
Martin cf	2	0	1	0	McCormack c	3	1	1	0
Hebner 1b	4	0	1	0	Moreno 2b	3	1	2	0
Maddox cf	2	0	0	0	Ciamm'li p	0	0	0	0
Lucy 3b	2	0	0	0	Arroyo p	0	0	0	0
Boone c	2	0	0	0	Manos p	0	0	0	0
Brusstar p	0	0	0	0	Schneider p	0	0	0	0
Hernaiz p	1	0	0	0					
Taylor ph	1	0	0	0					
Johnson 2b	4	0	0	0					
Garber p	0	0	0	0					
Harrelson ss	4	2	2	1					
Ripplem r p	0	0	0	0					
Totals	37	3	10	2	Totals	33	4	10	3

```
Philadelphia    ·    001 010 001 — 3
READING         ,    100 020 001 — 4
```

E — Foote, Guarnaccia, McCormack, Matuszek. LOB — Philadelphia 8, READING 5. 2B — Johnstone, Johnstone, Moreno. 3B — Convertino, Moreno. HR — Harrelson, Oliveros. SB — McCarver, Harrelson, Aguayo.

	IP	H	R	ER	BB	SO
Garber	2	2	1	1	0	3
Brusstar	2	2	0	0	0	1
Hernaiz	4	5	2	2	0	4
Rippelmeyer (L)	0	1	1	1	0	0
Ciammachilli	3	4	1	0	0	4
Arroyo	2	1	1	1	1	0
Manos	2	3	0	0	0	3
Schneider (W)	2	2	1	1	0	0

WP — Manos. T — 1:49. A — 5,090.

MAY 28, 1978: RPHILS 4, PHILS 3. RPhil Ed Oliveros breaks a tie by homering off Ray Rippelmeyer's first pitch in the bottom of the ninth inning, handing the Phillies pitching coach yet another exhibition-game loss. Reading fans saw a home run by Phillies backup shortstop Bud Harrelson, who otherwise hit seven home runs in 4,744 at-bats over a 16-year career. A lunar eclipse immediately followed. Behind the plate, going 1-3 and scoring a run for the RPhils was Don McCormack (RHOF, pictured below), who would play briefly for the Phillies in 1980 and 1981 and would manage the RPhils in 1990. McCormack's place in Phillies history is that he was on deck without a major league at-bat in the 11th inning of a tie game on the second-to-last day of the 1980 season, as Montreal Expos pitcher Stan Bahnsen instead elected to pitch to Mike Schmidt. Schmidt homered as the Phillies won 6-4 to clinch the division title. McCormack followed with his first major-league hit in his sole plate appearance, finishing the season with a batting average of 1.000. (Left, *Reading Eagle* files; below, Phillies.)

ALL PHILLIES, ALL THE TIME

APRIL 24, 1980: RPHILS 8, PHILS 4. For this game, four Phillies regulars did not make the trip because of ailments. However, both Mike Schmidt and Pete Rose appeared, each getting a hit. Phillies coach Ruben Amaro Sr., who coached at Reading in 1971, played second base and drove in a run. The RPhils were led by future Phillie Bob Dernier (RHOF), who hit a two-run homer and scored two runs. (*Reading Eagle* files.)

Reading Phillies

Philadelphia	ab	r	h	rbi	READING	ab	r	h	rbi
Rose dh	2	1	1	0	Dernier cf	4	2	2	2
Amaro 2b	2	0	0	1	Sandberg ss	4	1	0	0
Gross 1b	4	1	1	0	Lombarski dh	3	0	0	0
Smith rf	2	1	0	0	Bell rf	3	1	1	0
Schmidt 3b	1	0	1	1	Kraus rf	1	0	1	2
Luzinski lf	2	0	1	2	Virgil c	3	1	1	1
Unser lf	1	0	0	0	Ibarra c	1	0	0	0
Mori c-3b	4	0	1	0	Williams lf	3	1	1	0
Bowa ss	1	0	1	0	McDonald 3b	3	1	1	1
Jvukch 2b-c	3	0	0	0	Curry 2b	1	0	0	0
Aguayo 2b-ss	4	1	1	0	Castro 2b	2	0	0	0
GVukch cf	4	0	1	0	Jones 1b	3	1	2	2
Totals	30	4	8	4	Totals	31	8	9	8

```
Philadelphia       300 000 001—4
READING            003 300 20x—8
```

E—McGraw, Smith 2, Moreland. DP—Phila. 4, Reading 3. TP—Reading 1. LOB—Phila. 4, Reading 5. 2B—Aguayo, McDonald, Virgil. HR—Dernier. SB—Smith, Dernier 2, Jones 2, Bell, Williams, Curry.

Philadelphia	ip	h	r	er	bb	so
Ruthven	2	1	0	0	0	2
McGraw	1	3	3	3	0	0
Munninghoff (L)	4	4	5	5	3	1
Reading						
King	1	1	0	0	2	0
Speck (W)	6	5	3	3	4	2
Abreu (S)	3	3	1	1	1	0

Munninghoff (Dernier). WP—Speck, Munninghoff. T 2:05. A—7,132.

TRIPLE PLAYGATE. In the first inning, Phillies catcher Keith Moreland (RHOF, pictured at left) hit into a 7-5-4-1-4 triple play, ending a three-run rally. With the Phillies hitting into three double plays as well, several writers questioned whether the Phillies deliberately ran into the triple play as an attempt to get the game over with. Moreland, a former RPhil, hit .314 that year, playing four positions. A key reserve, Moreland was moved in and out of the lineup by manager Dallas Green on the team's way to the world championship. (NBOHF.)

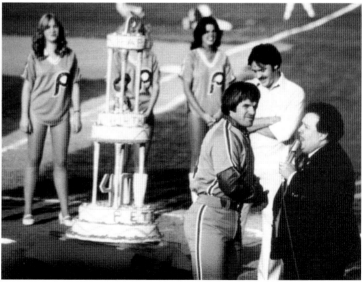

Phillies 6, Phils 4

Phillies	ab	r	h	bi		READING	ab	r	h	bi
L Smith cf	2	1	1	1		Bruno cf	3	1	2	1
Rose dh	3	0	0	0		Taylor dh	1	0	0	0
Schmidt 3b	3	1	2	3		Hamric 2b	2	0	0	1
Matthews lf	2	0	0	0		R Smith 2b	2	0	1	0
Vukovich c	2	0	1	0		Franco ss	3	0	0	0
Unser 1b	2	0	0	0		Culmer lf	3	0	1	0
Elia 1b	2	0	0	0		Lombarski 1b	3	1	2	1
Gross rf	3	1	2	0		Borucki 3b	3	1	1	0
Aguayo ss	3	0	1	0		Sanchez rf	3	1	2	0
Boone c	1	0	0	0		Ikonic c	1	0	0	0
Davis lf	1	1	0	0		Orensky c	2	0	0	0
Aviles 2b	2	2	1	0		Watmon cf	3	0	1	0
Total	26	6	8	4		Total	29	4	10	3

Phillies 001 021 2 — 6
READING 110 110 0 — 4

E — Franco, Culmer, Orensky. LOB — Phillies 5, READING 4. 3B — Bruno. HR — Lombarski, Schmidt. SB — Borucki, Sanchez 2, L. Smith. S — L. Smith. SF — Schmidt.

Phillies	IP	H	R	ER	BB	SO
R. Reed	1	1	1	1	0	0
McGraw	1	2	1	1	0	2
Lyle	1	0	0	0	0	0
Proly	1	1	1	1	0	1
Culver (W)	3	6	1	1	0	3

READING						
Prior	3	1	1	1	2	1
Alicea	1	1	0	0	0	0
Caboda	1	2	2	2	1	0
J. Reed	1	2	1	1	0	1
Foulk	1	2	2	2	1	0

WP — J. Reed. Balk — Prior. PB — Vukovich.
T — 1:43. A — 10,125.

APRIL 30, 1981: PHILLIES 6, RPHILS 4. With 10,125 in attendance, the largest crowd in the history of the stadium, Mike Schmidt played the entire seven-inning game as a tribute to the Reading fans. He led the Phils with three RBI and a home run. Recalling his 1971 debut, Schmidt said, "I'll never forget that this is where it started for me in a Philadelphia–Reading game." Schmidt's gesture to the fans was especially significant as only 16 Phillies make the trip; all starters were excused. Managing the RPhils was Ron Clark, who played one game for the 1975 Phillies, the last in his seven-year big-league career. Also making the trip to Reading instead of taking the night off was Pete Rose, who had turned 40 on April 14. Rose went 0-3, but all was not lost. Here, Rose is serenaded by the crowd, led by emcee Glenn Burkhart, in a rendition of "Happy Birthday." A number of Reading Philliettes look on. The crowd also participated in RPhils' center fielder Joe Bruno and his wife getting married in center field before the game. Bruno then went 2-3 with a triple, scored a run, and drove in a run. (Left, *Reading Eagle* files; below, Reading Fightins' files..)

VUKE. Working on making himself as useful a utility man as possible, John Vukovich (pictured at right) played the last three innings of the game for the Phillies, getting a hit in the process. Because of that kind of effort, Vukovich played with three major-league teams over parts of 10 seasons, despite a .161 lifetime average. Manager Dallas Green said of Vukovich that day, "He knows we are carrying him for several reasons and that he must work hard at several positions." Of his return that night to Reading, where he spent parts of three of his 12 minor-league seasons, Vukovich said, "It's a very special feeling for me to come back here and play with the world champions." (NBOHF.)

"AND PRINT IT." When Schmidt moved to first base later in the game, taking over at third base was Phillies third-base coach Lee Elia (pictured at left), who had managed the RPhils in 1977–1978. He also managed the Phillies in 1987–1988. After spending six seasons of his 12-year minor-league career in the Phillies system, Elia was traded with Danny Cater (the author's favorite player at the time) to the White Sox for Ray Herbert, playing with the Chisox in 1966 and with the Cubs in 1968. It was during his two years as manager of the Cubs that Elia, after an early-season loss in 1983, went into a tirade in which he cussed out Cub fans. This is often referred to as one of the greatest sports rants of all time. (Phillies.)

Philadelphia	ab	r	h	bi		READING	ab	r	h	bi
Dernier rf	5	2	4	3		Wshngtn dh	4	1	1	1
DeJesus ss	3	1	1	1		Lindsey ss	2	1	1	0
Gross 1b	2	0	1	1		Enos lf	1	0	0	0
Rose 1b	2	1	1	1		McDondl lf	2	0	0	1
Unser lf	3	1	1	0		Willard c	3	0	0	0
Mathews lf	2	0	1	0		Velszuq c	2	0	0	0
Aguayo ss	3	1	1	0		Salava rf	3	1	1	0
Matuszk 3b	5	1	1	1		Harvey cf	4	2	1	0
Davis dh	3	1	1	0		Nemeth 1b	5	1	1	3
Maddox cf	2	0	0	0		Fryer 3b	3	1	1	0
Roberts 2b	0	0	0	2		Jeltz 2b	5	0	2	0
Virgil c	4	2	2	1						
Trillo 2b	0	0	0	0						
Vukvich rf	1	1	0	0						
Total	35	11	14	10		Total	34	7	8	5

```
Philadelphia     004 006 100 —11
READING          012 100 003 —7
```

E— Aguayo, Fryer, Salava. DP— READING—2. LOB— Philadelphia 3, READING 11. 2B— Dernier 2, Virgil 2, Lindsey, Salava. 3B— DeJesus, Fryer. HR— Nemeth. SB— Dernier, Virgil. SF— Roberts 2, McDonald.

	IP	H	R	ER	BB	SO
Philadelphia						
Gross (W)	5	5	4	4	5	3
Wortham	2	1	0	0	2	4
Palmieri	2	2	3	3	1	3
READING						
Davis	3	5	4	2	1	2
Decker (L)	3	5	6	6	3	4
Willis	3	4	1	1	0	2

HBP— By Wortham (Salava), by Palmieri (Salava). WP— Gross, Balk— Decker. T— 2:30. A— 6,129.

APRIL 22, 1982: PHILLIES 11, RPHILS 7. In several homecomings, former RPhil Ozzie Virgil (RHOF) hit two doubles, Bob Dernier went 4-5 with two doubles, and George Vukovich scored a run. Loaned to the Phillies for the game and picking up the victory was RPhils pitcher Kevin Gross (RHOF), who would debut with Philadelphia the next season. Pitching for the RPhils was Mark Davis, one of two pitchers on loan for the game from the Phillies' Oklahoma City AAA team. Pete Rose received a standing ovation after going from first to third on a single, his dash ending with a head-first slide. At first base and homering for the RPhils was Joe Nemeth (not that Joe Namath). With the RPhils in 1980, Dernier (pictured below) hit .299 while not only leading the Eastern League with 111 runs scored, but also with 71 stolen bases. Over 10 seasons with the Phillies, then the Cubs, then the Phillies again, Dernier hit .255 with 218 stolen bases. A memorable moment in Denier's career was his May 15, 1989, three-run inside-the-park home run in the bottom of the 12th inning, which gave the Phillies a 3-2 victory over the Giants. (Left, *Reading Eagle* files; below, Phillies.)

ALL PHILLIES, ALL THE TIME

Reserve Power. With his role in 1982 being backup to catcher Bo Diaz, Ozzie Virgil Jr. (pictured at right) had all of one plate appearance in the Phillies' first 12 games that season, prior to his 2-4 night in Reading. Playing for the RPhils in both 1979 and 1980, Virgil had a breakout year in 1980 when he hit 28 home runs and led the Eastern League with 104 RBI. Twice named to the all-star team, Virgil spent six of his 11 major-league seasons with the Phillies before being traded to the Braves. (NBOHF.)

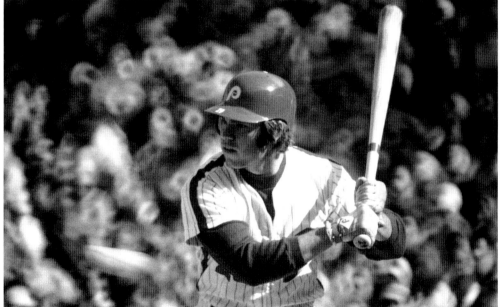

Part of Five for One. Scoring a run for the visitors was former RPhil George Vukovich, the Phillies' starting right fielder in 80 games in 1982. He was one of six Phillies to start there that season. Batting .272 with six home runs and 42 RBI that year, Vukovich (pictured above) would be one of five Phillies traded in the off-season to Cleveland for Von Hayes (who in 1983 would start 86 games for the Phillies, batting .263 with six home runs and 32 RBI). However, Hayes would have a longer career than Vukovich, who would play three seasons in Cleveland, two in Japan, and then one in the minor leagues before retiring. (Phillies.)

Exhibition

PHILADELPHIA	ab	r	h	bi		READING	ab	r	h	bi
Rose rf	2	0	1	0		Stone cf	3	0	0	0
Matszk 1b	3	0	0	0		JPerez 3b	3	2	1	0
Gross lf	4	0	1	0		Mlendz 3b	3	1	0	0
Mrgn 2b	1	0	0	0		Salava rf	4	0	2	3
Demr cf	4	1	1	0		Wlms rf	1	0	0	0
Schmidt 3b	1	0	0	0		Samuel 2b	3	0	0	1
Virgil c	3	1	1	1		Dowell 2b	1	0	0	0
TPerez 1b	0	0	0	0		Daulton c	1	0	0	0
Rbnsn 3b	3	0	1	1		LaVllre c	1	0	0	0
Hayes cf	1	0	0	0		Darkis dh	2	0	0	0
Molinan lf	5	0	0	0		Wshtn lf	3	1	1	0
Diaz c	1	0	0	0		Legg ss	4	1	2	1
Mlbrn 2b	3	0	0	0						
DeJss ss	3	0	1	0						
Bystrom p	3	0	0	0						
Farmer p	0	0	0	0						
Monge p	0	0	0	0						
Johnson p	0	0	0	0						
Total	35	2	6	2		**Total**	29	5	6	5

```
Philadelphia    001 000 001 — 2
Reading         003 100 00x — 5
```

Game-winning RBI — Salava.
E — Davisson, Samuel. DP — Reading 1. LOB — Philadelphia 12, Reading 7. 2b — J. Perez. Hr — Virgil. SB — Salava, Washington, Legg.

Philadelphia	IP	H	R	ER	BB	SO
Bystrom (L)	5	4	4	4	5	8
Farmer	1	0	0	0	0	3
Monge	1	2	1	1	1	1
Johnson	1	0	0	0	1	1
Reading						
Davisson (W)	4	4	1	1	6	2
Gaynor	1	0	0	0	1	0
Bartholow	1	0	0	0	0	0
Griffin	1	0	0	0	0	0
Riley	2	2	1	1	0	0

Balk — Davisson. T — 2:10. A — 6,785.

April 14, 1983: RPhils 5, Phillies 2. In a game played on his 42nd birthday, Pete Rose played right field and went 1-2 before being replaced after the second inning. Former RPhil Ozzie Virgil homered. Leading the RPhils attack that evening was future Phillie and future RPhils manager Gregg Legg (pictured below), who went 2-4 with a run and an RBI. Legg would play with the Phillies in parts of 1986 and 1987 and would manage Reading from 2002 to 2004. As of the date of this publication, Legg was named manager of the Phillies Class A affiliate in Clearwater, his 13th year as a minor-league manager within in the Phillies organization. (Both, *Reading Eagle* files.)

REDEMPTION IN READING. Of significance that evening was the performance of Phillies starting pitcher Marty Bystrom, seeking to show that he had recovered from injury so he could rejoin the Phillies rotation. Bystrom pitches five innings, striking out eight. Though he was the losing pitcher, it was determined that Bystrom showed enough to rejoin the Phillies rotation as the team's fifth starter for the pennant winning "Wheeze Kids." Bystrom would post a 6-9 record and 4.60 ERA, pitching one inning in relief in Game 5 of the World Series. (Phillies.)

PHILADELPHIA	ab	r	h	bi	READING	ab	r	h	bi
Samuel 2b	2	0	0	0	Miller 2b	3	0	0	0
Garcia 2b	3	0	0	0	Hoppie 2b	2	0	1	1
Stone lf	2	0	0	0	Jackson ss	2	2	1	0
Maddox cf	2	1	1	0	Escobar ss	2	0	0	0
Hayes cf	2	0	0	0	Soares rf	3	0	2	1
Gross lf	2	1	1	0	Day 1b	5	0	1	1
Schmidt 3b	3	2	2	2	Ward cf	4	0	0	0
Wilson rf	4	0	1	0	Jelks 3b	4	0	1	0
Wockenfuss c	4	1	2	2	Brown dh	4	0	0	0
Diaz dh	3	0	0	0	Kinnard lf	3	1	1	0
Russell 1b	3	1	0	0	Cipollonic	3	0	0	0
Jeltz ss	3	1	1	3	Tejada c	1	1	1	1
Total	33	7	8	7	Total	36	4	8	4

Philadelphia Phillies	000	010	006	—	7		
Reading Phillies	001	010	002	—	4		

Game-winning RBI — Schmidt.

E — Russell, Jeltz 2, Ward. DP — Philadelphia 1, Reading 1. LOB — Philadelphia 2, Reading 8. 2B — Schmidt 2, Wockenfuss, Soares, Day. 3B — Jackson, Tejada. HR — Jeltz. SB — Kinnard. SF — Soares.

Philadelphia Phillies	IP	H	R	ER	BB	SO
Zachry	3	3	1	1	1	2
Andersen	2	1	1	1	1	2
Hudson	1	0	0	0	0	1
Carman	1	0	0	0	0	1
King (W)	2	4	2	2	1	0
Reading Phillies						
Gaynor	5	2	1	1	1	3
Evetts (L)	3 2/3	6	6	6	2	0
Culver	1/3	0	0	0	0	0

HBP — Diaz by Evetts. T — 2:11. A — 5,432.

APRIL 18, 1985: PHILLIES 7, RPHILS 4. In their first year under former RPhils manager John Felske, the Phillies came to Reading with a record of 1-7, needing a win for no other reason than an ego boost. Going into the ninth inning, the Phillies trailed 2-1, when they exploded for six runs off RPhils reliever Tony Evetts. The key blow was a three-run home run by Phillies shortstop Steve Jeltz, who played for the RPhils in 1982. Adding to the Phillies' attack was former RPhil Mike Schmidt and catcher John Wockenfuss, who each have two doubles and two RBI. Picking up the win, pitching two innings in relief, was Phillies batting-practice pitcher Hank King. (*Reading Eagle* files.)

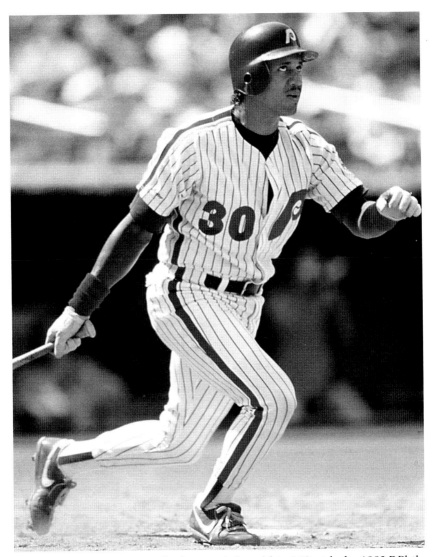

"THE LONG WALK HOME." Steve Jeltz (pictured above) hit .242 with the 1982 RPhils, playing shortstop but primarily second base. In the next few years at AAA and then with the Phillies, he demonstrated versatility in the field, playing three infield positions as well as in the outfield. He showed sufficient skills at the shortstop position, such that he was named the team's starting shortstop at the start of the 1985 season, despite his weak hitting. Jeltz made five errors in the Phillies' first eight games, then made two more against the RPhils, somewhat tempering the effect of his three-run homer that night. In a June 8, 1989, game against the Pirates, Jeltz carved a niche for himself in Phillies history when in the same game he hit two of his five career home runs from opposite sides of the plate—the first Phillie to accomplish that feat. It was a game in which the Phillies fell behind 10-0 in the first inning. Pirates broadcaster Jim Rooker stated that he would walk back to Pittsburgh if the Pirates lost. The Phillies won by a score of 15-11, and Rooker indeed walked the 308 miles in the offseason, raising money for charity. Jeltz was traded by the Phillies to Kansas City after the 1989 season. (Phillies.)

PHILADELPHIA	ab	r	h	bi		READING	ab	r	h	bi
Thompson cf	1	0	0	0		Leiva cf	4	0	1	1
Dernier lf	3	1	0	0		Legg 2b	4	0	1	1
Bradley lf	4	1	0	0		LeBoeuf dh	3	1	2	0
Samuel 2b	1	0	1	0		McElroy pr	0	0	0	0
Aguayo 2b	3	0	1	2		Parker 3b	4	0	1	0
Schmidt dh	1	0	0	0		Brown lf	3	0	1	1
Gross 1b	3	0	0	0		Holyfield rf	4	0	1	0
Hayes 1b	0	1	0	0		Berman 1b	4	0	0	0
Parish c	1	0	0	0		Calvert c	3	0	2	1
Daulton c	3	0	0	0		Roman c	1	·1	0	0
James rf	1	0	1	1		Edge ss	4	2	2	0
Young rf	3	0	1	0						
Almon 3b	4	0	0	0						
Jeltz ss	0	0	0	0						
Miller 2b	1	0	0	0						
Total	29	3	4	3		Total	34	4	11	4

```
Philadelphia Phillies .......... 010  000  002  —  3
Reading Phillies .............. 100  000  102  —  4
```

One out when winning run scored. Game-winning RBI — Calvert. E — Aguayo, Dernier, Leiva, Edge. DP — Philadelphia 1. LOB — Philadelphia 8, Reading 10. 2B — James, Aguayo, LeBoeuf 2. 3B — Young. SB — Hayes, Aguayo, Edge.

	IP	H	R	ER	BB	SO
Philadelphia Phillies						
Palmer	4	5	1	1	1	4
Dawley	2	0	0	0	1	2
Ritchie	1	2	1	1	1	1
McLarnan	1	1	0	0	0	2
Machado (L)	⅓	3	2	2	2	0
Reading Phillies						
Malone	1	1	0	0	0	0
Magee	1	1	1	1	2	1
Fortugno	1	0	0	0	3	0
Service	1	0	0	0	1	2
Sossamon	1	0	0	0	1	0
McElroy	1	1	0	0	1	1
Moore	1	0	0	0	0	0
Boudreaux	1	0	0	0	0	0
Sharts (W)	1	1	2	1	0	0

HBP — Dernier by Sharts. T — 2:40. A — 6,436.

APRIL 28, 1988: RPHILS 4, PHILLIES 3. Before 6,436 fans, Mike Schmidt had one at-bat in what would be his last game in Reading. The Phillies were managed by former RPhils manager Lee Elia in his second year at the helm, while the RPhils were managed by former RPhil Bill Dancy, who previously managed the team in 1983–1984 and would return to manage the RPhils in 1994–1995. In what would be a dismal year for both teams, each would finish in last place. Leading the attack for the RPhils was Al LeBoeuf (pictured below) with two hits and a run scored; he would manage Reading in 1997–1998. (Left, *Reading Eagle* files; below, David M. Schofield.)

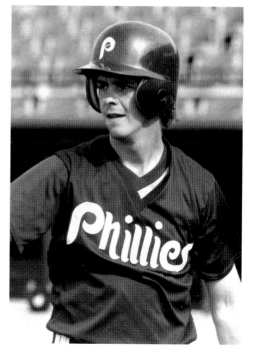

ALL PHILLIES, ALL THE TIME

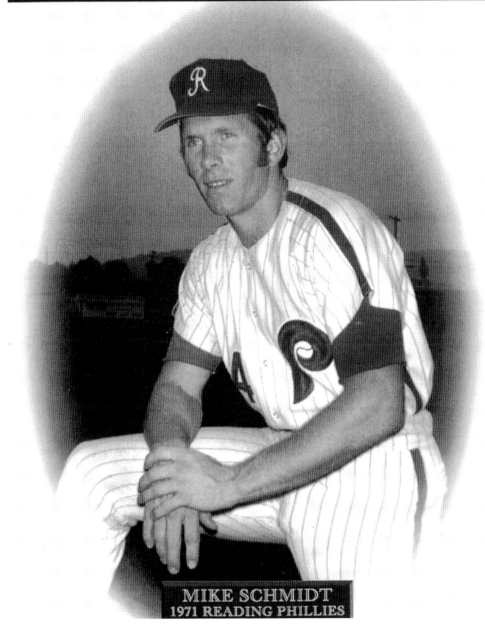

MIKE SCHMIDT
1971 READING PHILLIES

THAT HOME RUN IN 1971 JUST SEEMED LIKE YESTERDAY. Mike Schmidt flied out in his only at-bat. Having hit 37 home runs in 1986 to win the league home-run crown and 35 home runs the next season, Schmidt's offensive production in 1988 dropped dramatically, as he hit only 12 home runs. His batting average dropped from .293 in 1987 to .249 in 1988. He retired on May 30, 1989. Over 18 big-league seasons, Schmidt hit 30 or more home runs 13 times and drove in more than 100 runs nine times. (Reading Fightins' files.)

The box score at the top of the page is too faded and degraded to read reliably.

APRIL 23, 1990: PHILLIES 7, RPHILS 6. Following the game in which Phillies bullpen coach "Irish" Mike Ryan played the outfield and the winning pitcher was Fred Christopher, loaned by the RPhils to the Phillies, Ken Tuckey wrote in the *Reading Times*: "An exhibition baseball game between a major-league club and a farm team can't be taken seriously. It is merely played to whet the appetite of the faithful who pay the freight at both levels." Managing the RPhils was former RPhil and former Phillie Don McCormack. Homering for the Phillies were former RPhil Darren Daulton as well as Randy Ready, who also doubled and drove in three runs. (*Reading Eagle* files.)

IRISH ON THE BASE PATHS. In a game with no substitution restrictions, Phillies bullpen coach "Irish" Mike Ryan (pictured at right) played left field and got two hits in two at-bats. In 636 games over his 11-season big-league career, he appeared only as a catcher. When on base, in an effort to avoid being picked off, he announced, "Gentlemen, I'm an old man. Don't be fooling around out there." Ryan, a member of the 1963–1964 Reading Red Sox, would play for the Phillies for six years. Following a brief time managing in the minor leagues, Ryan spent 16 years as the Phillies bullpen coach. (NBHOF.)

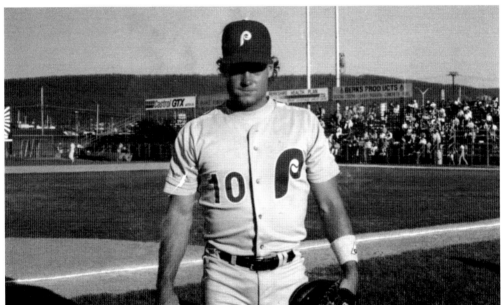

DUTCH. Powering the Phillies victory was former RPhil Darren "Dutch" Daulton (RHOF), who hit a three-run homer in his only plate appearance. Daulton (pictured above) played for the Phillies in 13 of his 14 big-league seasons. Named to the all-star team three times, he was a leader of the "Macho Row," part of the team that won the 1993 pennant. (Reading Fightins' files.)

PHILADELPHIA	ab	r	h	bi
Amaro cf	4	0	1	1
M. Ryan ph	1	0	0	0
Duncan lf	1	0	0	0
Backman lf	3	0	0	0
Kruk 1b	1	0	0	0
Jordan 1b	3	0	1	0
Murphy dh	4	0	0	0
Hollins 3b	1	0	0	0
Sveum 3b	3	0	0	0
Morandini 2b	2	1	0	0
Scarsone rf	2	1	1	0
Batiste ss	3	0	1	1
Lake c	3	0	0	0
Total	**31**	**2**	**4**	**2**

READING	ab	r	h	bi
Dostal cf	4	0	1	1
Lieberthal c	2	0	1	1
Lockett ph	3	0	1	0
Nuneviller lf	3	0	0	0
Alborano lf	1	0	0	0
Pratt 1b	2	1	0	0
Rosado ph	1	0	0	0
S. Ryan dh	4	2	3	0
Taylor rf	4	1	1	0
Trevino 2b	4	3	3	3
Waller 3b	4	1	1	1
Escobar ss	4	0	1	1
Total	**36**	**8**	**12**	**7**

```
Philadelphia Phillies  ........... 000  001  010  —  2
Reading Phillies       ...........  040  003  01x  —  8
```

E: Morandini 2, Batiste 2, Waller 2, Bushing. DP: Philadelphia. LOB: Philadelphia 4, Reading 6. 2B: Trevino. 3B: Trevino. SB: Morandini.

	IP	H	R	ER	BB	SO
Philadelphia Phillies						
Searcy (L)	3	5	4	1	0	3
Hartley	3	3	3	3	1	3
Mathews	2	4	1	1	0	0
Reading Phillies						
Carter (W)	5	0	0	0	0	5
Bushing	2	3	1	1	0	1
Sullivan	1	1	1	1	1	2
Stevens	1	0	0	0	0	1

HBP: By Mathews (Dostal), by Sullivan (Scarsone). T: 2:13. A: 6,889.

MAY 14, 1992: RPHILS 8, PHILLIES 2. Again managed by former RPhil and former Phillie Don McCormack, the RPhils won as the Phillies mustered all of four hits and made four errors. Getting the "W" was RPhils starting pitcher Andy Carter, who threw five perfect innings with five strikeouts against the Phillies. Phillies' infielders played different positions for the first time in their respective careers: Wally Bachman played left field and Steve Scarsone (pictured below) played right field. Scarsone, who spent parts of three different seasons with the RPhils, would be traded to Baltimore later that year. He played parts of seven seasons in the major leagues with four different teams besides the Phillies. (Left, *Reading Eagle* files; below, Phillies.)

ALL PHILLIES, ALL THE TIME

MICK-EE MOR-AN-DEE-NEE (AS HARRY WOULD SAY). Former RPhil Micky Morandini (RHOF, pictured at right) returned to Reading, where he hit .351 in 1989 and went 0-2. Morandini would spend nine of his 11 big-league seasons with the Phillies. In a game against the Pirates later in the 1992 season, Morandini successfully pulled off the first unassisted triple play in the majors since 1968 and the first in the National League since 1927. (Phillies.)

RAJ. In the first of his two appearances in exhibition games against the RPhils, playing again in Reading in the 1998 game, Ruben Amaro Jr. (pictured at left) went 1-4 with an RBI for the Phillies. He hit .219 that season. The future Phillies general manager played in Philadelphia in parts of five of his eight big-league seasons. (NBHOF.)

PHILA.	ab	r	h	bi	READING	ab	r	h	bi
Dkstra cf	2	0	0	0	Magee cf	4	1	1	0
Tinsley cf	2	0	0	0	Doster 2b	5	3	3	2
Mrndn 2b	2	0	1	0	Rolen 3b	4	0	1	1
K.Jrdn 2b	1	0	0	1	McNr dh	3	0	0	1
Jffries 1b	2	0	0	0	Held 1b	4	0	0	0
Schall 1b	1	1	0	0	Moler lf	3	1	2	1
Zeile 3b	1	1	0	0	McCnll rf	3	0	1	0
Battle 3b	2	0	0	0	Bennett c	1	0	1	0
Daltn lf	2	0	2	0	Estlel c	2	0	0	0
Esnrch lf	2	1	1	1	Fisher ss	4	0	1	0
Whiten rf	2	0	0	1					
Murry rf	1	0	0	0					
Incvgl dh	4	1	1	1					
Liebrthl c	4	0	2	0					
Stckr ss	2	1	1	0					
Sefclk ss	1	0	0	0					
Total	**31**	**5**	**8**	**4**	**Total**	**33**	**5**	**10**	**5**

Philadelphia Phillies 010 012 100 — 5
Reading Phillies 200 010 110 — 5

DP: Philadelphia 1, Reading 2.
LOB: Philadelphia 4, Reading 6. 2B:
Morandini, Daulton, Eisenreich,
Rolen, McConnell. HR: Doster 2,
Moler. SB: Eisenreich, Murray,
Stocker. CS: Whiten, Moler, Bennett, Estalella. SF: Jordan, McNair.

Philadelphia Phillies	IP	H	R	ER	BB	SO
Hunter	6	7	3	3	4	4
Crawford	3	3	2	2	0	1
Reading Phillies						
Dodd	2	2	1	1	1	0
Holman	1	1	0	0	0	0
Blazier	1	1	0	0	0	0
Gomes	1	2	1	1	1	1
Juhl	1	1	2	2	2	0
Mitchell	1	1	1	1	0	0
Foster	1	0	0	0	0	0
Heflin	1	0	0	0	0	1

WP: Hunter 3, Gomes 2. T: 2:26.
A: 8,825.

MARCH 31, 1996: 5-5 TIE. As the members of the 1995 RPhils team received their championship rings, some former RPhils had a big night. Mike Lieberthal went 2-4, and Darren Daulton (playing left field) went 2-2, each hitting a double. Playing for the RPhils and homering twice was second baseman (and future Phillie) Dave Doster (RHOF), immediately before starting the season at AAA. Starting pitcher for the Phillies was former RPhil Rich Hunter, a few days before making his April 6 major-league debut. That night, Phillies great and broadcaster Richie Ashburn made his only known appearance at Reading Municipal Stadium. The RPhils were managed by Bill Robinson, their hitting coach in the previous season, in his only season at the helm. Playing five of his 16 big-league seasons in Philadelphia, Robinson was traded by the Phillies to Pittsburgh for pitcher Wayne Simpson, who appeared in a few games for the Phillies. Robinson (pictured below) played for eight seasons with the Pirates and was part of the nucleus of the 1979 world championship "We Are Family" team. He would return to the Phillies in 1982–1983. (Left, *Reading Eagle* files; below, Phillies.)

A BASEBALL ODYSSEY. Playing for the RPhils before actually beginning the season at AAA, RHOF Dave Doster (pictured at right) would hit two home runs that night. A key figure in the RPhils' 1995 Eastern League Championship, Doster would hit five home runs in the 1995 playoffs. Called up to the Phillies in June 1996, Doster played in Philadelphia for the rest of that season and in 1999. Over 11 years in the minor leagues, Doster played for 10 different teams in not only the United States, but also Mexico and Japan, retiring after the 2005 season. (Phillies.)

LOST SEASONS. A fan favorite during his time as an RPhil, Mike Lieberthal (RHOF) would go 2-4 that evening. A two-time all-star selection who would hit above .300 twice, Lieberthal (pictured at left) spent 13 of his 14 big-league seasons with the Phillies. Although he caught more than 100 games in seven different seasons, Lieberthal lost large portions of several seasons to injuries. (NBHOF.)

BOX SCORE

PHILADELPHIA	ab	r	h	bi		READING	ab	r	h	bi
Glanville cf	2	0	0	0		Taylor cf	5	0	1	0
Amaro cf	2	0	0	0		Knupfer 2b	4	0	1	0
Jefferies lf	2	0	0	0		Dawkins lf	4	0	1	0
Huff 2b	3	0	0	0		Carver 1b	4	0	1	0
Rolen 3b	2	0	1	0		Royster rf	4	0	0	0
Arias 3b	3	1	1	0		Amador 3b	4	1	1	0
Lieberthal c	2	0	0	0		Rivero	4	0	1	0
Parent c	1	0	0	0		Millan c	2	0	1	0
Mills ph	1	0	0	0		Guilliano ss	4	0	1	1
Jordan 1b	3	1	1	0						
Hudler dh	3	2	0	0						
Abreu rf	2	0	1	1						
Key rf	2	1	1	3						
Sefcik 2b	4	0	1	0						
Relaford ss	2	0	1	0						
Rollins ss	2	0	0	0						
Totals	36	5	7	4		Totals	35	1	8	1

```
Philadelphia Phillies ...........010  100  030 – 5
Reading Phillies ..............000  000  100 – 1
```

E: Arias, Royster, Amador. DP: Philadelphia 1. LOB:
Philadelphia 7, Reading 9. 2B: Sefcik, Relaford, Millan.
HR: Key. SB: Hudler, Dawkins.

Philadelphia Phillies	IP	H	R	ER	BB	SO
Perez	3	1	0	0	1	6
Thomas W	6	7	1	1	1	6
Reading Phillies						
Barnett L	6	4	2	1	2	3
Costa	2	3	3	2	0	1
Nyan	1	0	0	0	0	0

T: 2:07. A: 8,678.

APRIL 14, 1998: PHILLIES 5, RPHILS 1. All Phillies regulars came and signed autographs in accordance with orders from manager Terry Francona. Four Phillies minor-leaguers (including shortstop Jimmy Rollins) played for the visitors. Former RPhil Al Leboef was in his second year of managing his former team, while future RPhils manager Mark Parent played catcher for the Phillies. In his second exhibition game in Reading, future Phillies general manager Ruben Amaro Jr. went 0-2. Receiving a standing ovation was RPhils pitcher Evan Thomas, throwing that night for the Phillies. He gave up one run in six innings. After spending parts of three seasons with the RPhils, Thomas would spend six seasons at the AAA level with three organizations in addition to playing in the Phillies system. He would not reach the major leagues despite several years in which he posted excellent numbers. (*Reading Eagle* files.)

GREAT PLACE TO PLAY BALL. Former RPhil Scott Rolen (RHOF, pictured at right) went 1-2 in his return to Reading. Joining the RPhils at the end of the 1995 season, in time to help with the Eastern League Championship drive, Rolen remained for part of the 1996 season. He torched the Eastern League with a .361 average and was playing in Philadelphia by season's end. Calling Reading "a great place to play ball," Rolen declared it to be "my favorite place I've played in the minor leagues." (Phillies.)

EARLY J-ROLL. Still two years shy of his major-league debut, 19-year-old Jimmy Rollins (pictured at left) was called up from Clearwater to play for the big club in the game in Reading. Entering the game in the fourth inning, he would go 0-2 but played well in the field. Of the stadium where he would play the next season, Rollins said, "I love this field. You get the major league crowd here. The major league feel." (Reading Fightins' files.)

Reading Phillies 5, Philadelphia Phillies 2

PHILADELPHIA	ab	r	h	bi	READING	ab	r	h	bi
Glanville cf	0	1	0	1	Francia cf	3	1	1	0
Sefcik cf	1	0	0	0	Punto ss	2	0	0	1
Gant lf	2	0	0	0	Dominique ph	1	1	1	0
Hunter 1b	1	0	0	0	McNamara dh	3	1	2	0
Abreu rf	2	0	1	1	Valent rf	3	1	1	0
Padilla rf	1	0	0	0	Rose 3b	2	1	1	4
Brogna 1b	2	0	0	0	Harris 2b	1	0	0	0
Cappuccio lf	1	0	0	0	Burnham 1b	3	1	1	4
Lieberthal dh	1	0	0	0	Kiil lf	2	0	0	0
Henderson ph2	0	0	0	0	Estrada c	2	0	0	0
Jordan 3b	3	1	1	0	Alvarez c	0	0	0	0
Morandini 2b	1	0	1	0	Knupfer 3b	2	0	0	0
Arias 2b	2	0	0	0					
Prince c	3	0	1	0					
Relaford ss	0	0	0	0					
Machado ss	2	0	0	0					
Totals	24	2	4	2	Totals	22	5	5	5

Philadelphia 110 000 0–2 4 0
Reading 100 400 x–5 5 2

E: Rose, Kiil. LOB: Philadelphia 4, Reading 1.
DP: Reading 1. 2B: Abreu, McNamara. 3B:
Francia. HR: Rose. SF: Glanville, Punto.

	IP	H	R	ER	BB	SO
Philadelphia						
Baisley L	5	5	5	5	1	3
Zamora	1	0	0	0	0	0
Reading						
Ascencio W	3	2	2	1	2	2
Dagley	4	2	0	0	0	1

WP: Ascencio. PB: Estrada.

T: 1:36. A: 9,307.

MAY 8, 2000: RPHILS 5, PHILLIES 2. RPhils won the seven-inning game on a grand slam by Pete Rose Jr. Most Phillies starters were given the night off, as several RPhils played for the parent club. The day of the game, *Reading Eagle* sportswriter Mike Drago prophetically wrote: "Like typewriters and rotary phones, games such as these will quietly disappear with little warning or fanfare. . . . Inevitably, unfortunately, a Phillies exhibition in Reading could someday be a thing of the past, such as vinyl records." (*Reading Eagle* files.)

ALL PHILLIES, ALL THE TIME

BASEBALL ODYSSEY II. Pete Rose Jr., hero of the game with his grand slam, would spend the 2000 season and part of the next season in Reading. Playing briefly with the 1997 Cincinnati Reds, the younger Rose would otherwise spend 21 seasons in the minor leagues, playing for 22 different teams. (David Schofield.)

A COMPOSITE OF MEMORIES. Reading-Philadelphia exhibition game experience spanning three decades was captured in this photograph of the coaching staff of the 1995 Eastern League champion RPhils. Hitting coach Bill Robinson (left), manager Bill Dancy (center), and pitching coach Larry Andersen (right) were involved as players, coaches, and managers. Robinson, who coached the RPhils for several years, was the RPhils' manager for the 1996 game and played for the Phils in the 1974 game. Dancy participated twice as a player for the RPhils and was their manager for the games in 1983 and 1988. Andersen appeared in the 1985 game as a player with the Phillies and was the RPhils' pitching coach for several games. (Reading Fightins' files.)

DISCOVER THOUSANDS OF LOCAL HISTORY BOOKS FEATURING MILLIONS OF VINTAGE IMAGES

Arcadia Publishing, the leading local history publisher in the United States, is committed to making history accessible and meaningful through publishing books that celebrate and preserve the heritage of America's people and places.

Find more books like this at
www.arcadiapublishing.com

Search for your hometown history, your old stomping grounds, and even your favorite sports team.

Consistent with our mission to preserve history on a local level, this book was printed in South Carolina on American-made paper and manufactured entirely in the United States. Products carrying the accredited Forest Stewardship Council (FSC) label are printed on 100 percent FSC-certified paper.

MADE IN THE USA